SECRET VISIONS

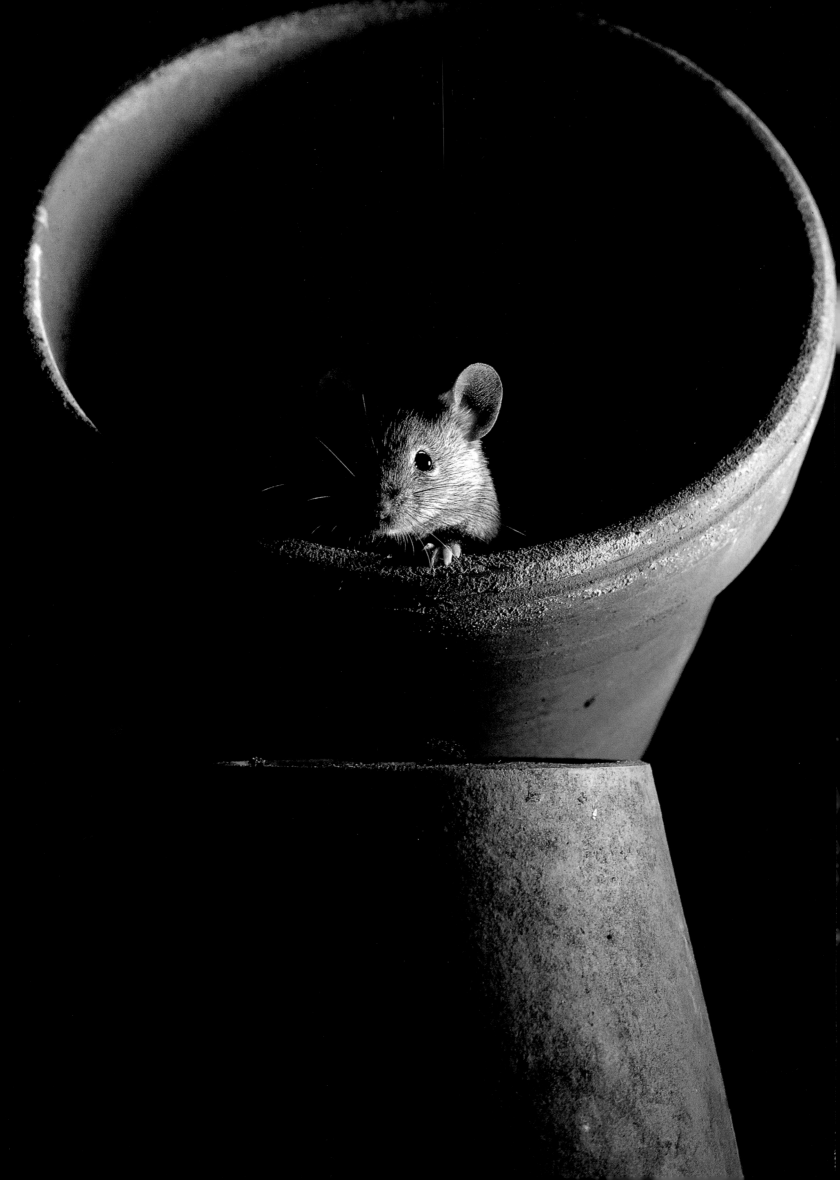

SECRET VISIONS

Salem House Publishers
Topsfield, Massachusetts

First published in the United States by Salem House
Publishers, 1988, 462 Boston Street, Topsfield, MA
01983.

Library of Congress Cataloging-in-Publication Data

Dalton, Stephen.
 Secret visions.

 Includes index.
 1. Nature photography. 2. Photography, High-speed.
I. Title.
TR721.D282 1988 770′.92′4 87–20774
ISBN 0–88162–318–0

This book was designed and produced by
JOHN CALMANN AND KING LTD, London

Designed by Roy Trevelion
Typeset in England
Printed in Singapore by Toppan Ltd

CONTENTS

INTRODUCTION

There is no simple answer to the question which I am frequently asked – 'What made you take up nature photography?' Certainly I never had a burning ambition to become a wildlife photographer. Like most schoolboys, I went through the usual stages of wanting to be an engine driver and fighter pilot, and, also like many children, I developed a love of animals almost before learning to walk.

I was sent to a boarding school in Shropshire which I did not enjoy. It was all rugger, Latin and team spirit, whereas I was, and still am, a bit of a loner. We did not even study biology, so it seemed a waste of time as far as I was concerned.

My life changed radically when, at the age of twelve, the family moved to an old Surrey mill house surrounded by ponds, streams and deciduous trees. This lovely setting provided an ideal habitat for a host of insects, birds and mammals. Here, the kingfisher flew and nested within fifty yards of the house, badgers and foxes lived in the woods, and even otters visited us during those early years. In these delightful surroundings one would have had to be very thick-skinned not to be captivated by such encounters.

My introduction to photography was more dramatic. One day my father, also a keen naturalist and amateur bird photographer, sought to satisfy my inquisitive nature by confining me to a hide set up in the middle of a stream outside the entrance to a kingfisher's nest. He told me to keep quiet and to wait for the bird to land on a stump barely three feet away from my peeping eye, and then to press the camera button. Crouched in that secret place, beside an antiquated plate camera mounted on a massive tripod, I eagerly awaited my quarry. Within half an hour the resplendent blue bird swept into view, and I excitedly pressed the release. The image was a total blur, but the experience made a lasting impression. Years later I spent many more June days in the same spot photographing these magnificent birds. Two of the resulting pictures appear in this book, on pages 36 and 105.

The **adonis blue** (*Lysandra bellargus*) is among the brightest of the blue butterflies and is widely distributed in southern and central Europe. Unfortunately it is becoming increasingly scarce in England due to the destruction of suitable downland habitat.

This is one of my earliest colour photographs and was exposed in the field with flashlight – an ideal technique for recording active insects outdoors.

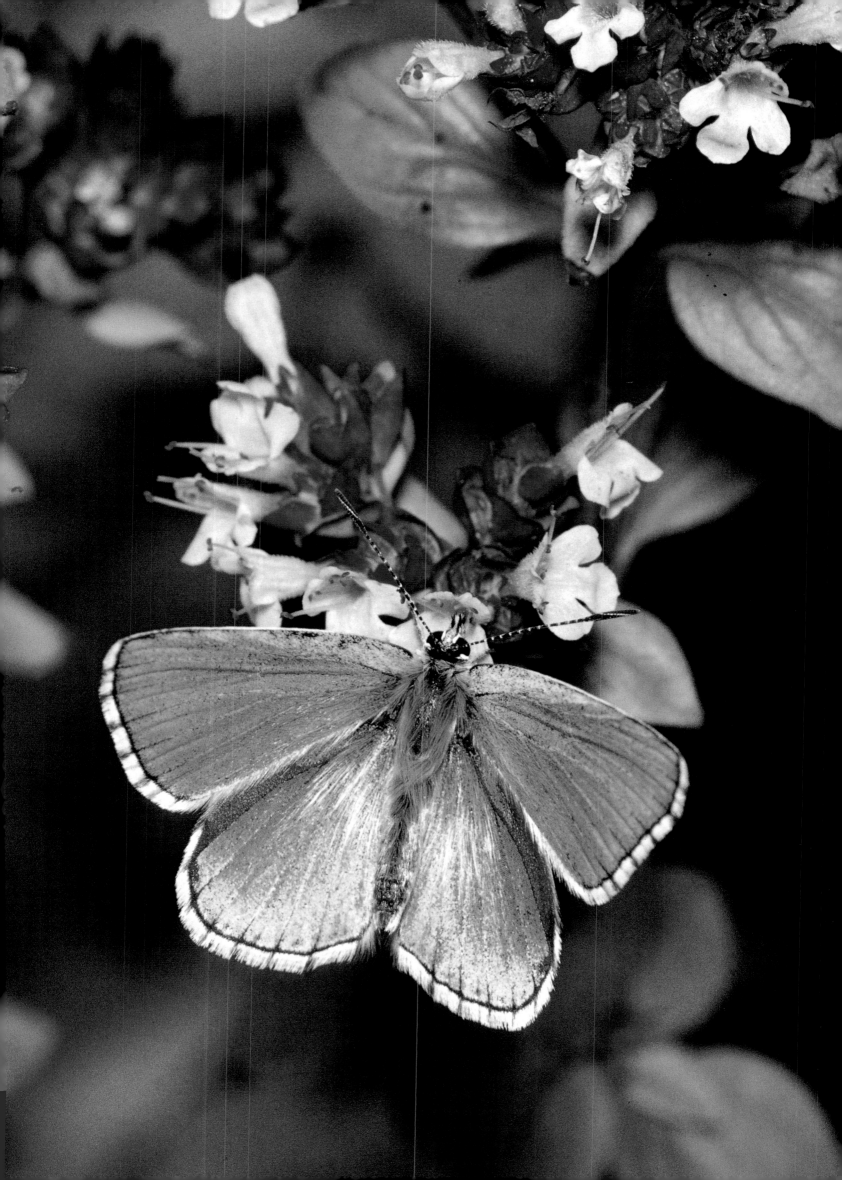

A lasting interest in photography did not develop until many years later when, in my early twenties, I bought my first real camera, a single-lens reflex Exacta. With my newly-acquired toy I photographed all manner of subjects and it was not long before I started to dabble with insect photography, struggling to get sharp images of small, active creatures. At the time, in 1960, I had a painfully boring office job in London, working

Hawk moths are among the fastest of flying insects, reaching speeds in excess of 30 mph (48 kph). This **small elephant hawk moth** (*Deilephila porcellus*), a delicate pink and yellow-shaded species, is fairly common throughout Europe, sometimes flying into houses at night.

This picture was taken early in my career as a professional nature photographer, and was set up in the studio where lighting, background and the whole design of the photograph can be more effectively arranged.

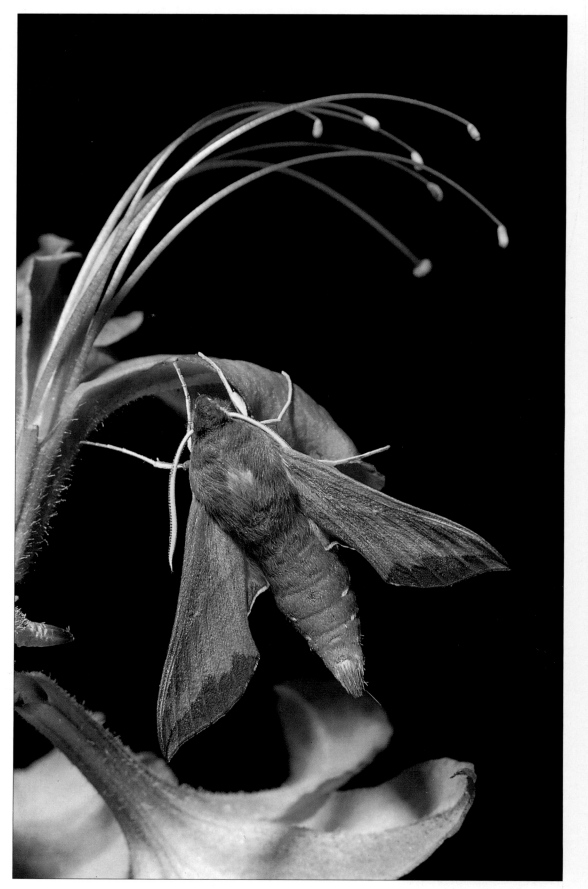

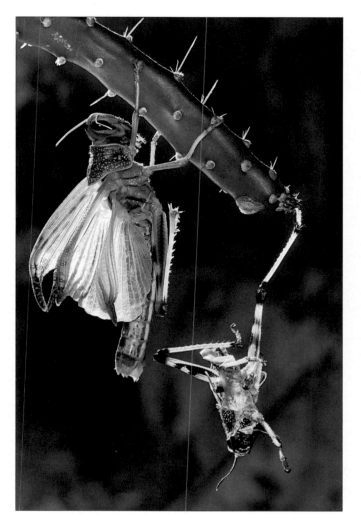

This insect is the notorious **desert locust** (*Schistocerca gregaria*) with a reputation dating back to pre-biblical times. Here it is expanding and drying its wings after shedding its skin from the previous instar.

As a college student, my final year's main project was to photograph the activities of the Anti-Locust Research Centre in London. It included showing the life history of the locust, from egg-laying to the voracious activities of the adult. This is one of the first times I used a degree of backlighting to emphasize the texture and translucency of a natural history subject.

for a firm which made combine harvesters, bulldozers and other noisy machines which despoil and dig up the countryside. Then I had a lucky break. I spotted an advertisement for a full-time course at the School of Photography at Regent's Street Polytechnic and an escape from the years of tedium presented itself. I applied and was offered a place. At last I had the opportunity to involve myself in a subject which interested me. Here, apart from studying previously mysterious matters such as photographic theory and darkroom technique, I learnt to become hyper-critical about my work. This perfectionist attitude has remained with me ever since.

During my early period at college I never imagined for a moment that a living could be made from nature photography, but nevertheless my two pursuits, natural history and photography, coalesced to such a degree that I soon lost interest in photographing people, baked-bean tins and other 'commercial' subjects. It was animals or nothing. Fortunately, shortly before leaving college I met L. Hugh Newman, the then well-known butterfly farmer and radio naturalist. On seeing my photographs of insects he told me that they were marketable, and offered to act as my agent. From then on I never looked back, gradually adding to my picture collection each year.

In those early days as a semi-professional I experimented with various types of nature photography, but my greatest efforts were directed towards insects, which up to that time had largely escaped the camera lens. Then in 1965, Hugh Newman found me my first real assignment – I was asked to provide the illustrations for a book on honeybees for an American publisher, which were to include the entire life history of the bee in great detail. It was a challenging commission, and took two seasons to complete. *Honeybees from Close-Up* was immediately followed by another book, *Ants from*

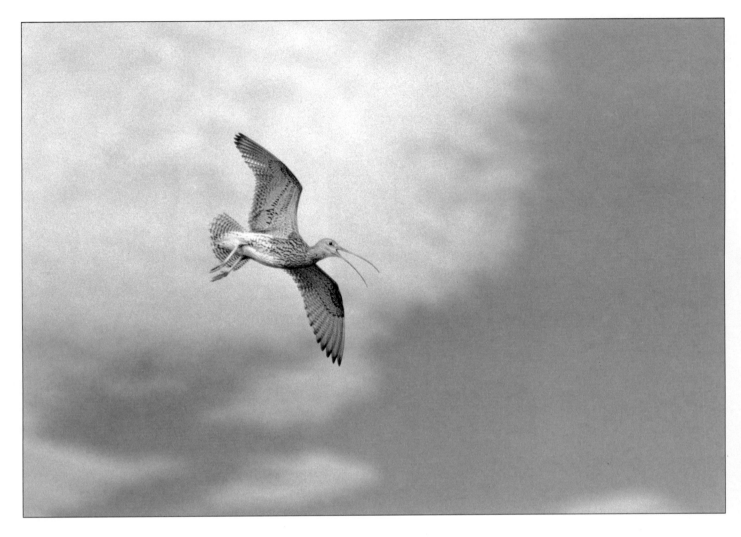

The forlorn call of the **curlew** (*Numenius arquata*) is one of the most haunting sounds to be heard on the remote moors and lowland areas it frequents. During the mating season the male displays, rising and falling in the air with a bubbling cry. Outside the breeding season curlews live on the coast and estuaries, where they search for crabs, shellfish, worms and shrimps.

Before becoming a fully-fledged professional, I could not afford much colour film and was often too impatient to wait for colour transparencies to be processed. Consequently most of my work was in black and white and home-processed.

Close-Up. Although both books were in black and white – at this time colour photography was far less common generally – they helped to establish me as a professional nature photographer.

On the strength of the bee and ant books I was asked to produce my first colour book, *Looking at Nature.* This was of much wider scope and included all sorts of mammals, birds and insects, although the pictures look very staid compared with contemporary work. In those days the emphasis was on portraits – sharp pictures of animals in natural settings. There was far less interest in action, behaviour or mood, and nobody seemed to have much idea about lighting. *Looking at Nature* was no exception – in fact by modern standards it was an indifferent collection of animal portraits. Nevertheless it was well received at the time.

By 1970 it was beginning to dawn on me that I had spent the last ten years or so photographing insects either resting or crawling, but neither I nor anybody else had ever photographed them in free flight. Flight is the insects' most important attribute – they learnt to fly about 150 million years before anything else became airborne. Furthermore, their ability to take to the air played a major role not only in their evolution but also in that of land vertebrates. Yet there was no means of observing the way an insect used its wings to make the incredible manoeuvres we take for granted. No technique was capable of stopping an insect with absolute clarity in free flight. The solution of this problem became my overriding obsession over the next few years.

I was determined to achieve two things. First, I wanted to record flight behaviour and wing movements – to show every twist of the wing, every scale and hair in critical focus. Second, and just as important, I wanted to create real pictures – the insect must

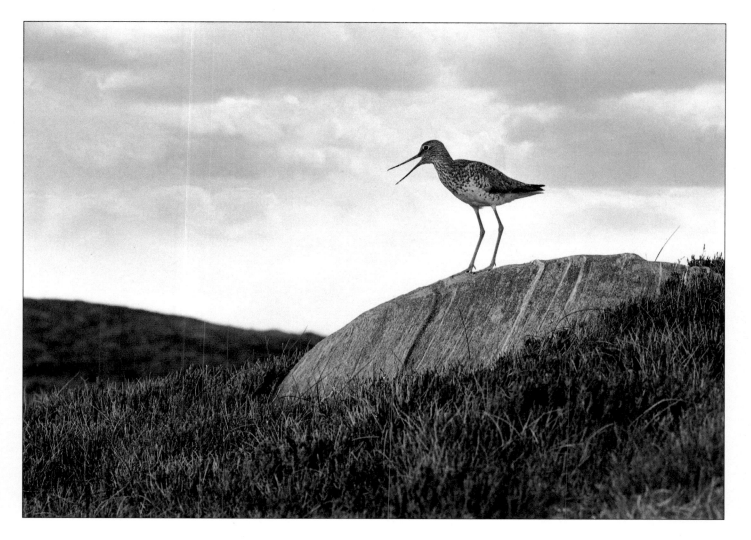

be flying in a setting which evoked the beauty of its natural habitat. So followed one of the most exciting times of my career. Over the next two years I developed equipment and techniques for capturing on film what, for me, was the miracle of insect flight. I recall the dream-like experience, when looking at dripping negatives fresh out of the developing tank, of seeing for the first time images of insects 'frozen' on the wing, an aspect of nature never seen before. Imagine, for example, my excitement at seeing the pin-sharp negative of the housefly (page 30) with its incredibly twisted wings, launching itself almost vertically from a loaf of bread in its frantic efforts to avoid danger.

The following year or two were almost entirely devoted to insect flight photography, all of which had to be done in the studio. It is impractical and usually impossible to photograph insects on the wing in the field. In their natural habitat they hardly ever fly where you want them, and it takes hours or sometimes days to set up and adjust all the optical and electronic paraphernalia needed to get things just right, after which the particular insect wanted will probably not appear at all! Yet in many ways studio nature photography is a lot more demanding than operating outside, whether working with flying insects or sitting toads.

You begin with an empty table on which a natural and biologically appropriate setting must be built up and photographed in such a way that an alluring picture is created. As in many spheres of photography, the secret of success lies in imagination rather than in technical know-how. Constructing the final picture in my mind's eye is the most taxing part of studio photography, technical problems frequently paling into insignificance. The shape, colour and arrangement of the picture elements, together with a natural but interesting choice of lighting, all play a role in evoking the ambience

Here you can almost hear the plaintive 'tew tew' cry of the **greenshank** (*Tringa nebularia*) echoing around the rocky hills and moorland slopes of the wild country where it breeds. Together with the curlew opposite, this picture was taken during the sixties when I made several trips to the Scottish Highlands with my father, also an enthusiastic photographer and ornithologist, to photograph the birds we rarely see further south.

My first real assignment was to provide the illustrations for a book on the **honeybee** (*Apis mellifera*) in black and white. Towards the end of the project I realized that I had recorded every aspect of the bee's life except the most important – its flight. I had never seen photographs of insects actually on the wing. I began to realize why over the next few weeks.

This photograph was taken with a conventional flash unit of about 1/1,000th of a second duration (far too slow to stop insects), and the camera was fired by hand – a very hit-and-miss affair as it turned out. It was several years before I tackled a flying insect again.

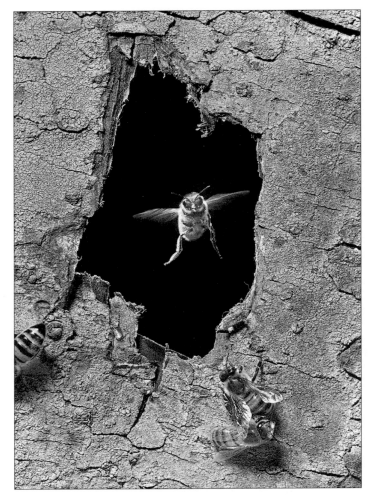

Although widespread in Europe, the **little owl** (*Athene noctua*) did not breed in England until the end of the last century, when it was deliberately introduced. The bird's diet consists of insects and worms, together with small mammals and birds, much of the hunting taking place during dawn and dusk. The bird here has caught a ghost moth (*Hepialus humuli*).

Unfortunately, the apple tree in which the birds were nesting was growing in the middle of a field of cattle, and to prevent them knocking down my equipment, a fence had to be erected around it. In spite of my precautions, one animal managed to knock down the flash stands during my first evening's vigil.

of the particular animal in its natural habitat. Before taking the camera out of its bag or placing a twig on the table, I often sketch out my ideas on paper: this not only helps with the design but may forestall problems. What always has to be borne in mind whilst planning the set is the likely behaviour of the subject. Animals cannot be forced to do anything. The setting should be organized to encourage the creature to fly, jump or sit in the right spot, and with minimum stress to itself. Once everything is in place the actual photography may take from an hour to a week or two to complete. This is the time when an understanding of and empathy with animals is invaluable. Encouraging a butterfly to sail two inches above a palm leaf or coaxing a mouse to jump between one tussock of grass and another often seems to involve more than just patience.

My work on flying insects culminated in 1975 with my first 'international' book, *Borne on the Wind, The Extraordinary World of Insect Flight*. Its publication attracted much attention from naturalists, photographers and scientists, and led to my involvement in a minor way with research at Cambridge. Here Professor Weiss Fogh and Charles Ellington were exploring the micro-aerodynamics of insect flight, which were still largely a mystery. I found their new ideas about 'unsteady airflow' and the 'clap-fling' mechanism fascinating.

My contact with Cambridge happened to coincide with a request from a then relatively-unknown publisher, the late John Calmann, who asked me whether I was interested in doing a book on animal flight. My enthusiasm for his proposal was such that I suggested that the book should compare animal with manned flight, tracing its evolution from the insects, which learnt to fly 300 million years ago, to Concorde. The project called for an enormous amount of research in such diverse areas as physiology, aerodynamics and the history of the early tower jumpers. I even completed a short

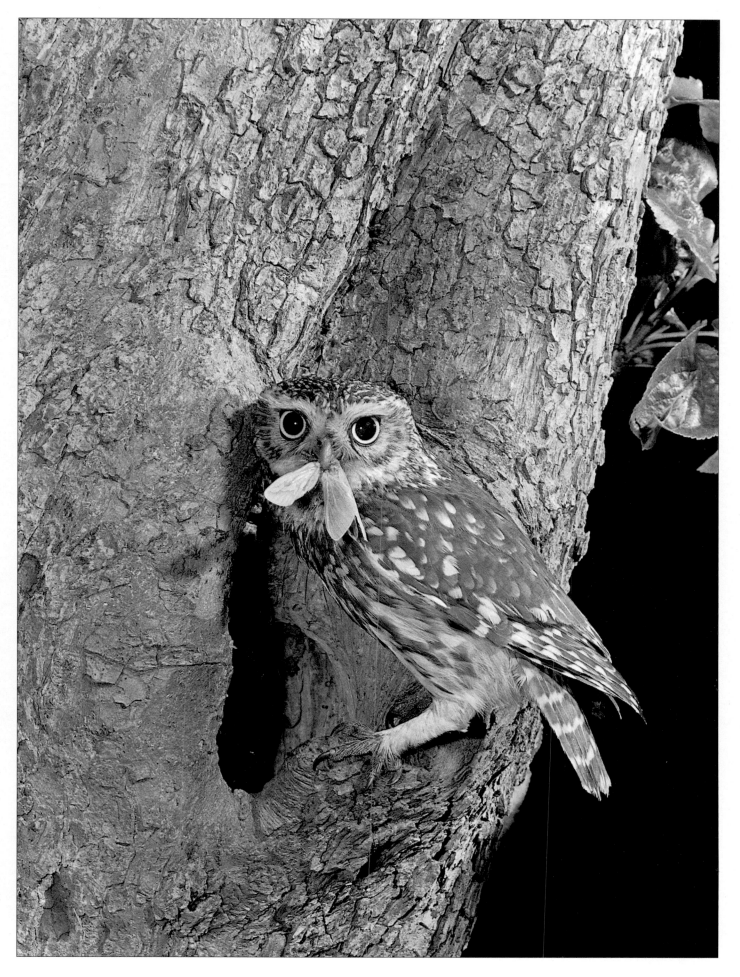

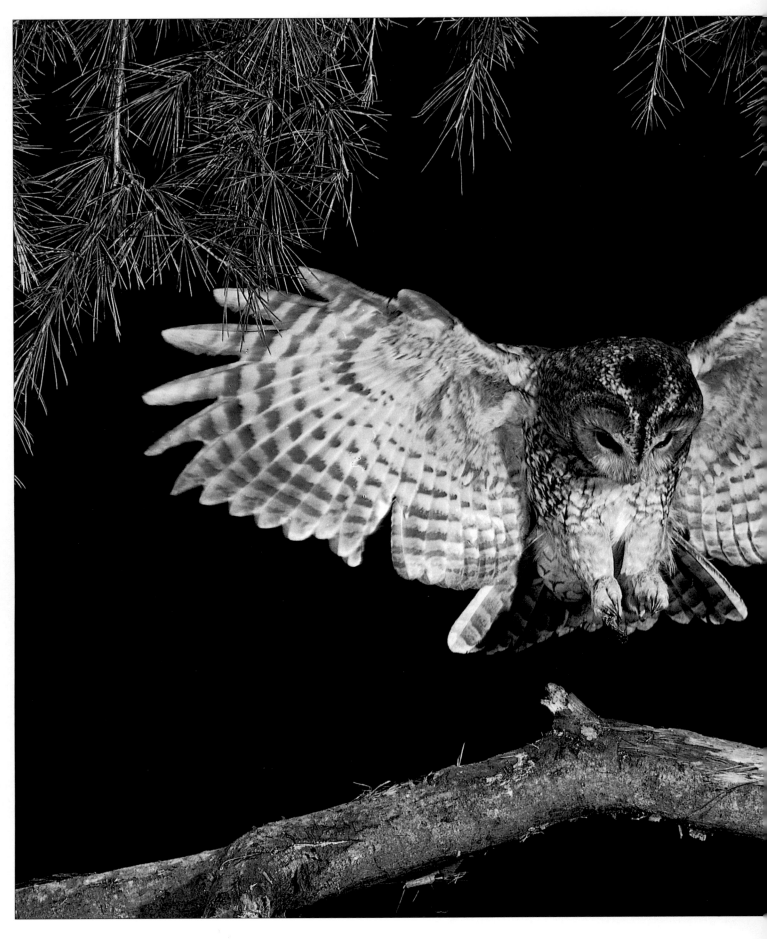

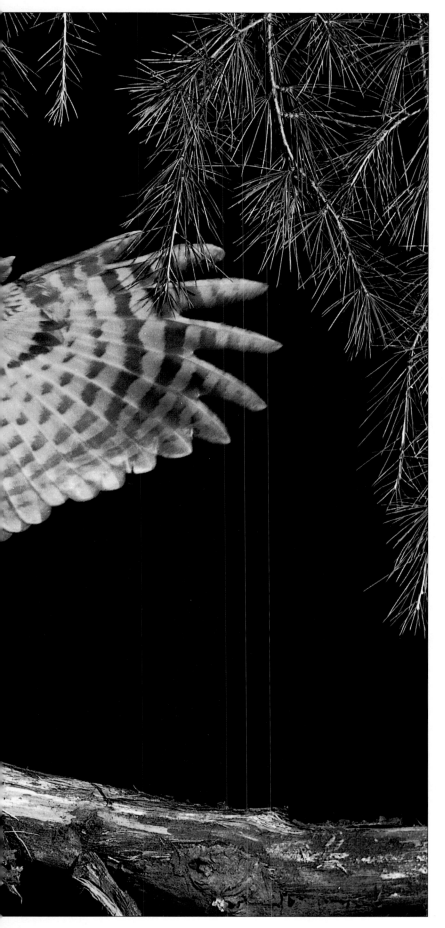

So that they can approach their prey silently, owls have specially constructed feathers with a fine pile to muffle the noise of the air as it rushes between them. Here a **tawny owl** (*Strix aluco*) is coming in to land, the separated ends of the primary feathers reducing stalling speed.

My fascination with flight inspired me to attempt the photography of flying birds with the help of flashlight to arrest wing movement. The owl provided me with my first opportunity to try, but at this stage all I had was a conventional flash with a relatively slow speed (1/1,000th of a second) – too slow to stop wing motion. Fortunately, only slight blurring is produced in this position.

Unfortunately the delightful little **harvest mouse** (*Micromys minutus*) has greatly decreased in numbers during this century. The causes, as so often with our declining fauna and flora, lie with modern farming methods. Its spherical summer nest is suspended between the stalks of corn or reeds and the young are reared inside. The winter nest is made in an underground burrow, where large stores of seeds and grain may be hoarded.

Unlike most rodents the harvest mouse is largely diurnal, living in thick vegetation where it uses its prehensile tail as a fifth leg in its search for seeds and insects.

course on hang-gliding so that I could write about the subject with some degree of authority! Eventually this book, *The Miracle of Flight*, was translated into several languages.

Several years passed before my next book, *Caught in Motion*, was produced. It was a collection of high-speed nature photographs with an accompanying text describing the techniques, but in a non-technical way, together with some of my experiences with the animals portrayed. The book was translated into a number of languages, including Japanese. Another book, *Split Second*, about the world of high-speed photography, but not confined to natural history, was followed a few years later, in 1986, by *The Secret Life of an Oakwood*. Here I had a chance to get away from undiluted high-speed work. The book followed the cycle of life in a local oakwood, a habitat vibrantly rich in plant and animal life, through the four seasons, and allowed me to explore fresh avenues of photography, particularly among plants and landscapes. But most important, my main aim was to capture the essential feel of these enchanting places.

Some of the photographs for *Oakwood* posed quite new problems. For example, in the past I had never had much luck with badgers, but when the book was commissioned it became imperative to photograph one. A suitable set was located at the edge of the wood among some beech trees. Rather than settling for a dull shot of the animal peering out of a bare entrance hole, I decided to try photographing it either crossing or drinking at a stream some fifty yards from the set. A hole had to be dug in the stream bank for the camera, and three flash heads were semi-permanently installed at strategic points. The badger would, I hoped, fire the camera when it stepped on a sensitive plate buried among the pebbles in the stream. To encourage regular activity, the area was generously baited with sultanas, a delicacy it finds difficult to resist. The first attempt, in early autumn, was a dismal failure. It necessitated a mile walk in the early evening to set up the camera and equipment, and a return visit each morning to remove the camera and take the heavy battery away for recharging. All I had after spending ten days on the project was a minute image of a woodmouse leaping from stone to stone.

The following summer saw a second attempt. After going through the same routine I manged to acquire shots of more woodmice, a robin and a stray black cat, but no badger. So far I had devoted nearly three weeks to this elusive animal and was on the verge of giving up. Particularly irritating was the absence of any sound reason for my failure. Great care was taken not to walk anywhere near the badger's runs, the flash power pack was well soundproofed and all the photographic hardware was camouflaged. By now the situation was desperate, as all the book illustrations had to be handed in to the publisher by late autumn, so I forced myself to have one last attempt during September. I was certain that at least one badger was crossing the stream every night; nevertheless, to reduce disturbance to a minimum I strategically baited for five nights before attempting any photography. Finally on the sixth night, and after a total of 294 camera hours, walking some forty-two miles, and much frustration, I got the picture.

During 1976, BBC Television made a film about my work, and one of the first questions the producer asked was how I felt about my photography. I remember being struck dumb by the question. Only recently have I begun to think about the ways in which my feelings may have influenced my work.

As a child my affection for animals arose from an inquisitive nature, but this soon evolved into a more scientific approach. I began collecting butterflies and moths – everything had to be identified and labelled, and I developed a thirst for knowledge in all aspects of natural history. This outlook was mirrored in much of my early work, when photography was largely used as a tool for recording subjects. Later as I progressed through my compulsive high-speed phase, which reflected a fascination with insect flight and animal movement, my perspective began to change. As well as

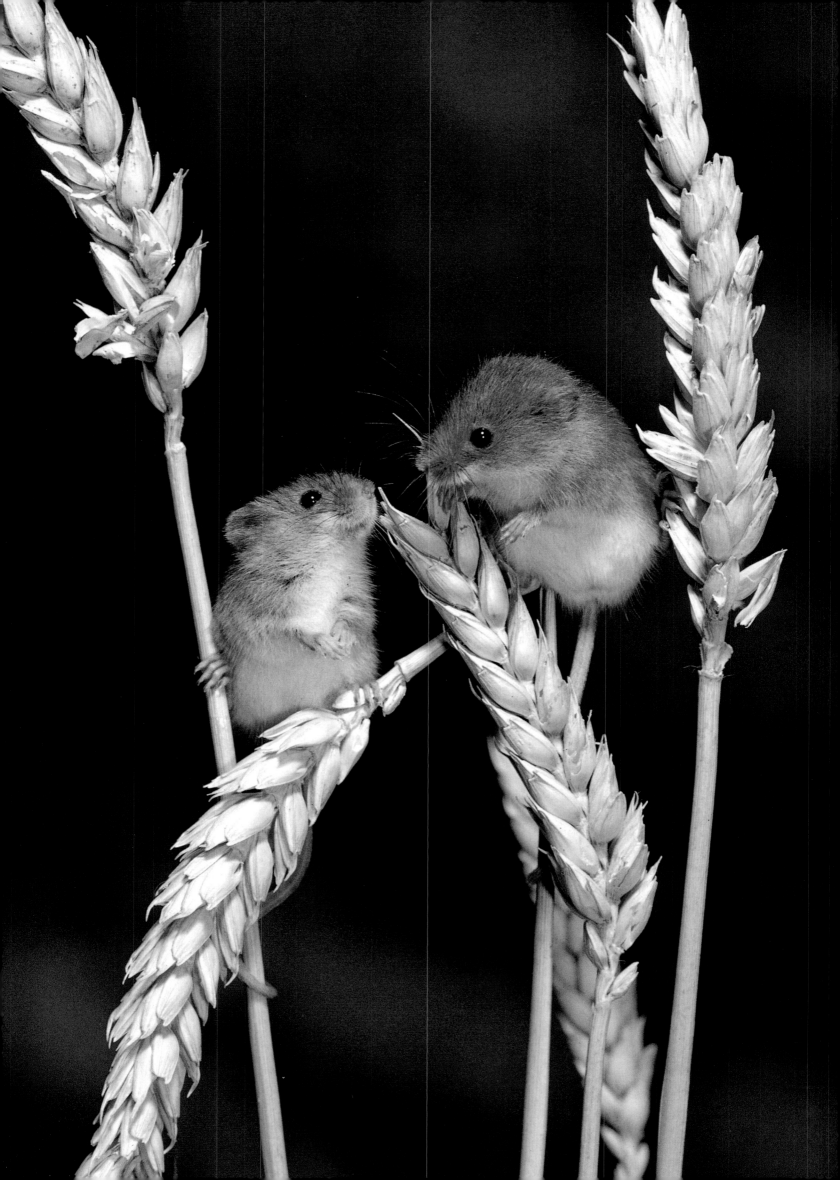

One of the most endearing of small mammals must be the **water vole** (*Arvicola terrestris*). It is more often heard than seen, as it plunges into water at the approach of danger, only to reappear several yards away. Although water voles will eat fish, eggs, snails and other creatures, they are mainly vegetarian, their favourite foods being reeds, grasses and willow leaves. The only way I could attract this animal to the bank of the pond I had specially prepared was to bait it with willow leaves: all other inducements were consistently ignored.

A giant among British insects, the male **stag beetle** (*Lucanus cervus*), *following page*, cannot be confused with other beetles on account of its huge, antler-like jaws, although the female has much smaller mandibles. During courtship males will often quarrel, but rarely, if ever, injure one another.

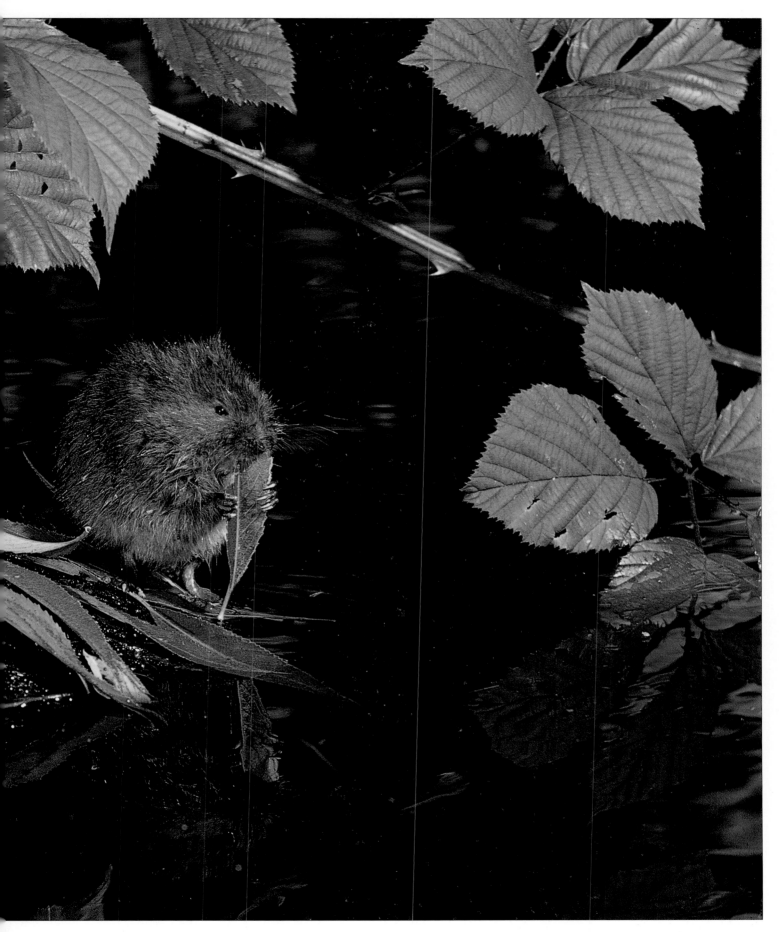

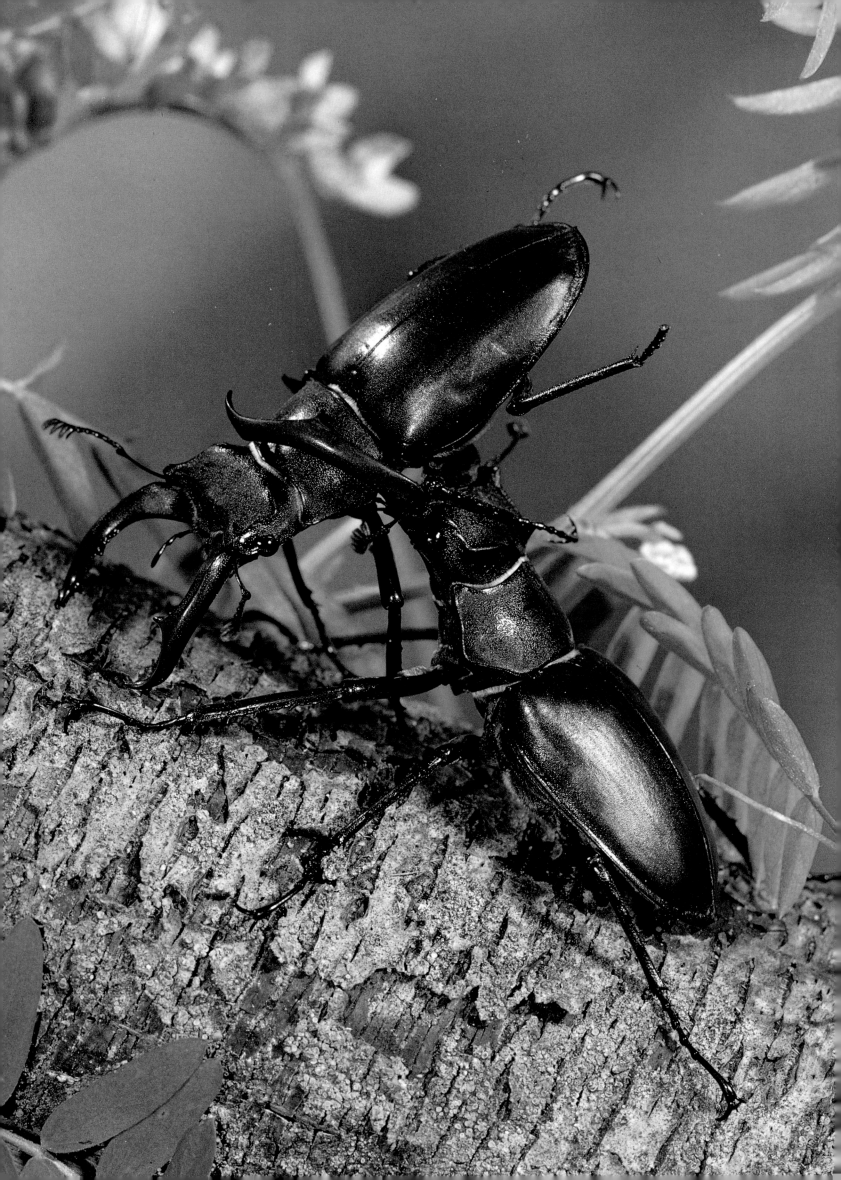

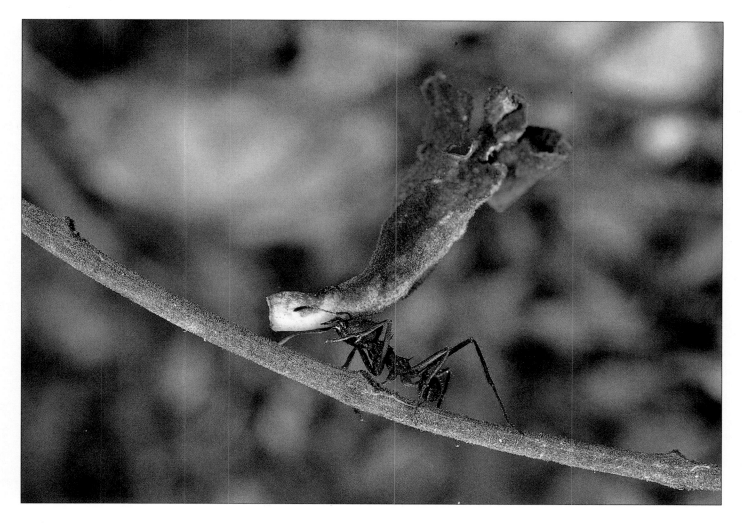

wanting to record fresh biological truths, I hoped that the photographs would show how exquisite these miniature aeronauts were. The numerous letters duly received from hitherto non-insect lovers, expressing surprise and wonder at the beauty of flying insects, made all the effort even more worthwhile.

As the years go by I become more moved by the sheer beauty of wild places and the overwhelming complexity of any form of life, whether it be a cheetah, primrose or cat flea. We seem completely to miss an essential point when we talk about saving this animal or conserving that habitat because it may provide us with some commercial or medical advantage – as though everything on earth was placed here for our exclusive benefit. Such arrogance never ceases to amaze me. What is far more important is that wild places and the animals which depend on them are beautiful and irreplaceable, and their existence is essential to our spiritual well-being and happiness.

It seems that man has lost his way. He is blinded by commercial interests and fails to understand what really matters for the long-term future of this planet. He continues at an accelerating rate to destroy natural creation, replacing beauty with ugliness. I am often reminded of the extraordinarily prophetic words written in the *Spectator* in 1887 – one hundred years ago:

> Man cannot wait for the cooling of the world to consume everything in it from teak trees to hummingbirds, and a century or two hence will find himself perplexed by a planet in which there is nothing except what he makes. He is a poor sort of creator.

Ants are among the most highly evolved insects but the parasol or **leaf-cutting ant** (*Atta* sp.) from Central and South America must be one of the most intriguing. Found marching in long, orderly lines, each ant carries a piece of leaf or a flower petal in its jaws. After the journey, the workers struggle down their hole where vegetable matter is deposited in underground galleries. Here the ants cultivate a fungus on it which they feed to their young.

This photograph was taken by the well-tried 'flash on camera' technique.

It is strange to watch a corpulent young **cuckoo** (*Cuculus canorus*) being fed by its diminutive foster parent, in this case a hedgesparrow (*Prunella modularis*). Certainly it has a bizarre life cycle.

After spending the winter in southern Africa, the cuckoo flies all the way to Europe where it pairs. The hen then seeks out the nest of a host bird. After laying a single egg, she removes one of the other eggs, leaving the host species to incubate hers. On hatching, the blind, unfeathered young cuckoo pushes out the other eggs so that the foster parents can give it their sole attention.

The fledgling cuckoo here had outgrown the nest and taken up position on a fence post.

Although the concern with our environment is gathering momentum at last, a more urgent approach is desperately needed. By inspiring and fostering deeper feelings, rather than merely relying on ecological argument, I think that nature photographers can help to awaken a sense of wonder towards living things, and a respect for them that may prove vital in the years ahead.

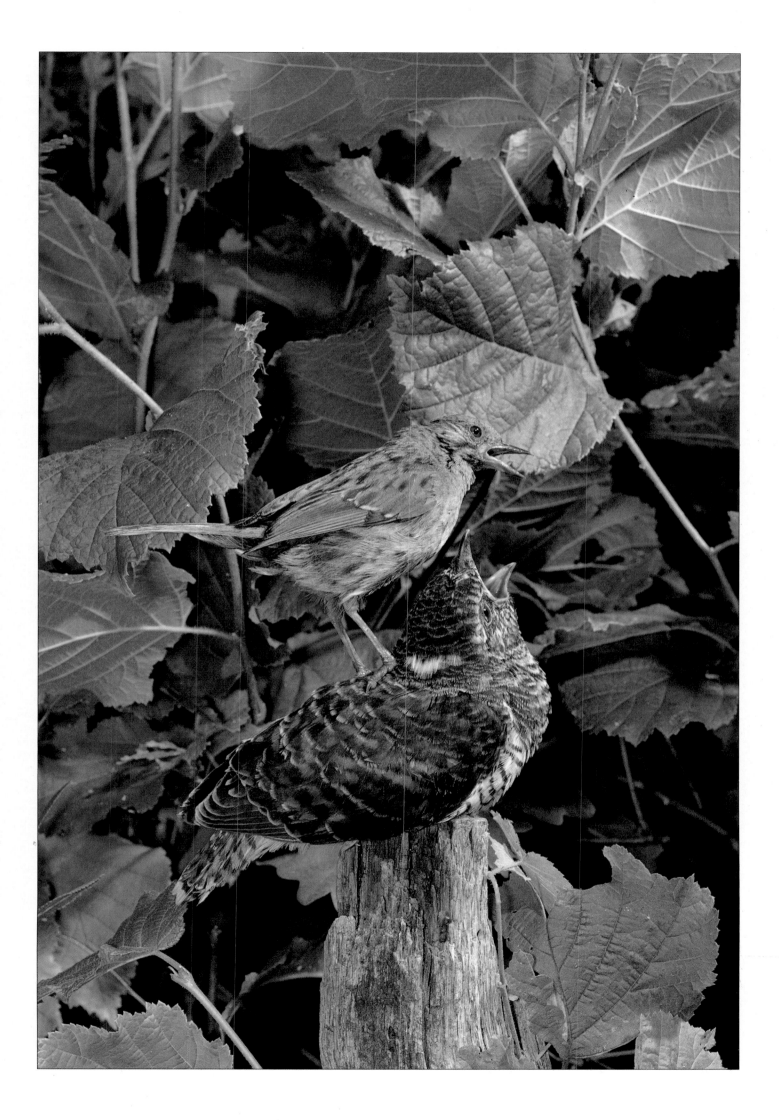

Breaking the High-Speed Barrier

1970–75

Shortly before midnight a **barn owl** (*Tyto alba*) approaches its nest in a church tower, with a small rat to feed its young.

Three weeks were devoted to producing this picture. As my two earlier attempts at flight photography left a lot to be desired, I decided to improve my technique, so I procured some antiquated 'semi high-speed' flash equipment and constructed a primitive triggering device.

I was beginning to understand the crucial role that lighting played in nature photography, so I worked out the precise positions of the flash heads with the help of a model of the tower built in my garden.

All the photographs in this section were exposed in the early 1970s when I was struggling to develop equipment and techniques to photograph insects in free flight.

My attempt some years previously with the honeybee (page 12) had already indicated some of the problems which needed to be solved, but my fascination with the subject made me determined to have a further try. It was a tremendously exciting time, and, as with so many things, the trick was to isolate each of the problems and tackle them one by one. My smattering of knowledge of electronics and an interest in home-made gadgets both helped me to achieve my goal.

In simple terms the main problem was that very high flash speeds are needed to stop insects' wings (up to 1,000 beats per second), and human reflex action is nothing like fast enough to fire the camera at the precise moment the insect flies into focus. Thus it was necessary to develop both a flash unit sufficiently fast, yet powerful enough to arrest all wing movement (about 1/25,000th of a second), and a system using light beams and photo-cells sensitive enough to detect small, active insects. Also, as the insects had to fly in normal, bright light conditions, a shutter had to be made which opened within about 1/500th of a second of the beam being broken by the flying insect – all conventional shutters being some twenty times too slow.

Within two years these problems and several others were solved, and I had a series of fascinating pictures, mostly in black and white, of insects in free flight.

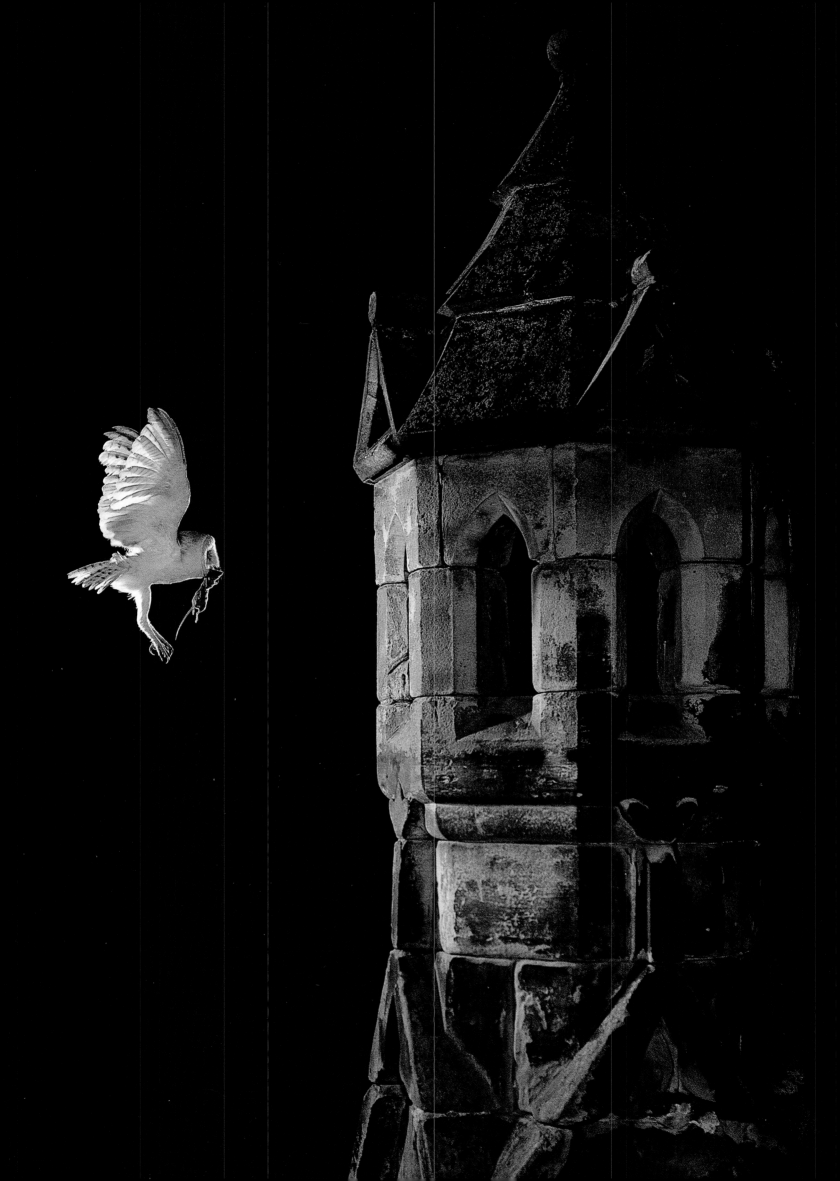

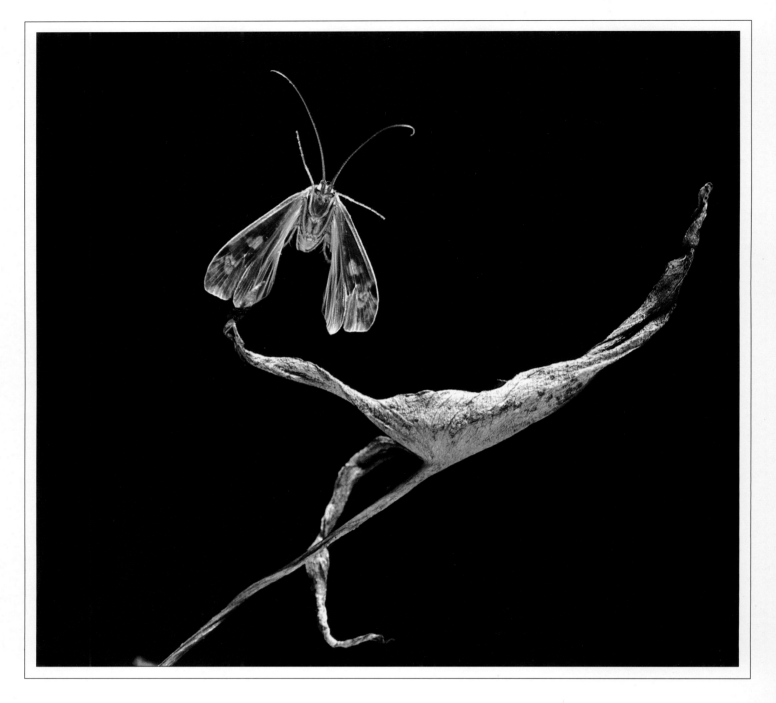

Caddisflies are largely nocturnal insects, frequently attracted into our houses at night by artificial lights. They are closely related to moths, in fact some species of moths were formerly classified with the caddisflies. They possess two pairs of membranous wings normally covered with hairs, rather than scales, and when at rest these are folded, roof-like, over their bodies.

The immature stages of caddisflies are spent underwater, the larvae protecting their frail bodies in portable cases made of sticks, stones, leaves or shells, held together with secreted silk. The adult here is skimming over a dead aquatic leaf.

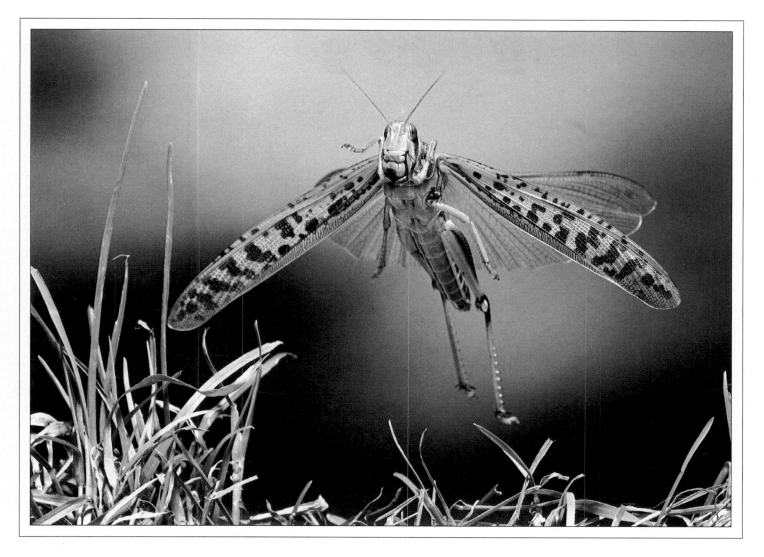

These two pictures of the **desert locust** (*Schistocerca gregaria*) and **caddisfly** (order *Tricoptera*) were among the first insects to test out my new equipment and techniques, and opened up the unknown and exciting new world of insect flight.

In the flight tunnel constructed in the studio locusts proved reluctant to use their wings, often preferring to jump than to fly.

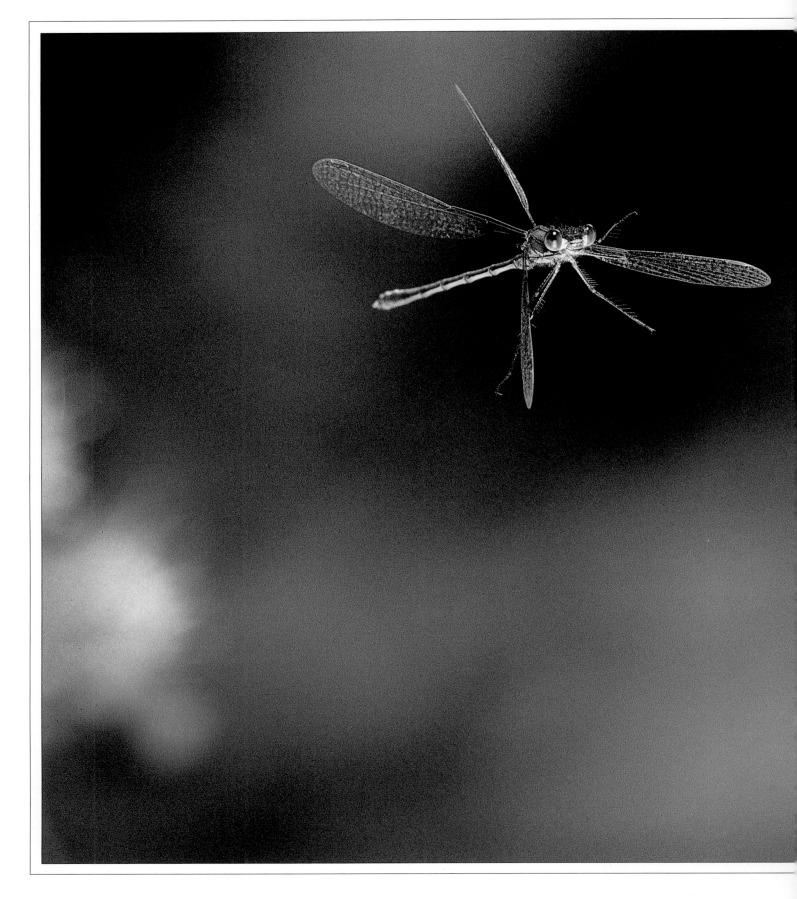

In this picture of the **green lestes damselfly** (*Lestes sponsa*), the independent movement of the two pairs of wings is clearly shown, the fore and hind wings being out of phase by about half a cycle.

Damselflies seem so frail on the wing. Certainly they are not endowed with the lightning reactions and speeds of the house fly, but they have different skills to suit their more leisurely way of life. Without drama they can hover, move upwards, downwards, sideways or even backwards in pursuit of small insects such as gnats or midges which settle nearby.

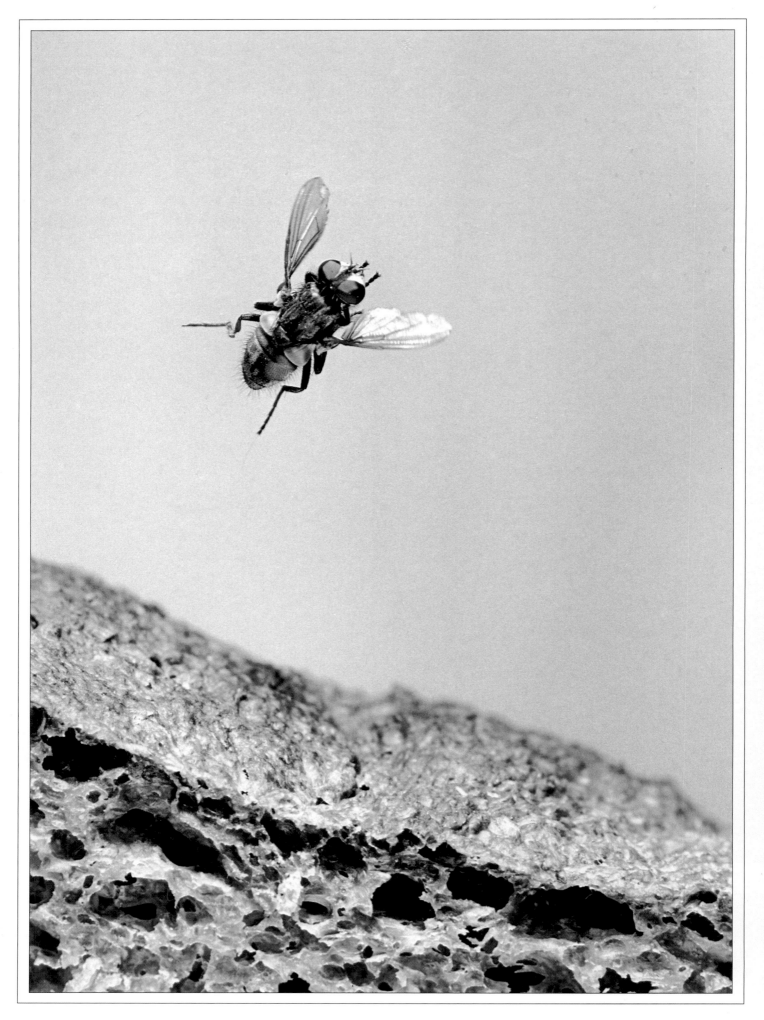

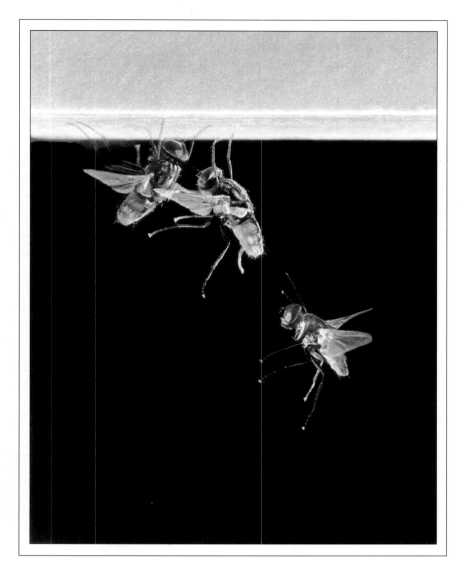

The incredible speed at which a **house fly** (*Musca domestica*), *left*, reacts to danger and rockets out of harm's way is manifestly demonstrated in this photograph. Just look at those wings – in its efforts to get away from the loaf of bread they have almost twisted inside out. Yet when actually seen, the fly seems to execute the move with such consummate ease.

A modification to my high-speed flash equipment allows me to fire each flash head sequentially, enabling a series of images to be recorded on the same frame of film. The use of multiflash came into its own in the photography of take-off and landing techniques.

How a fly lands on the ceiling had been a perennial puzzle. It was previously thought that it does so by performing a barrel roll or half-loop, but as this picture of a **house fly**, *above*, reveals, the manouevre is more elegant. The fly approaches the ceiling at an angle of forty-five degrees with front feet extended, and, as contact is made, it simply cartwheels over on to its other four feet.

After the initial success with insects, I soon became impatient to try out my new techniques on birds. The **greater spotted woodpecker** (*Dendrocopus major*) was one of the first, seen here diving out of its nest hole.

Unlike the green woodpecker, the greater spotted is rarely seen on the ground. It is a welcome and frequent visitor to the bird table, feeding on nuts and seeds as well as on insects.

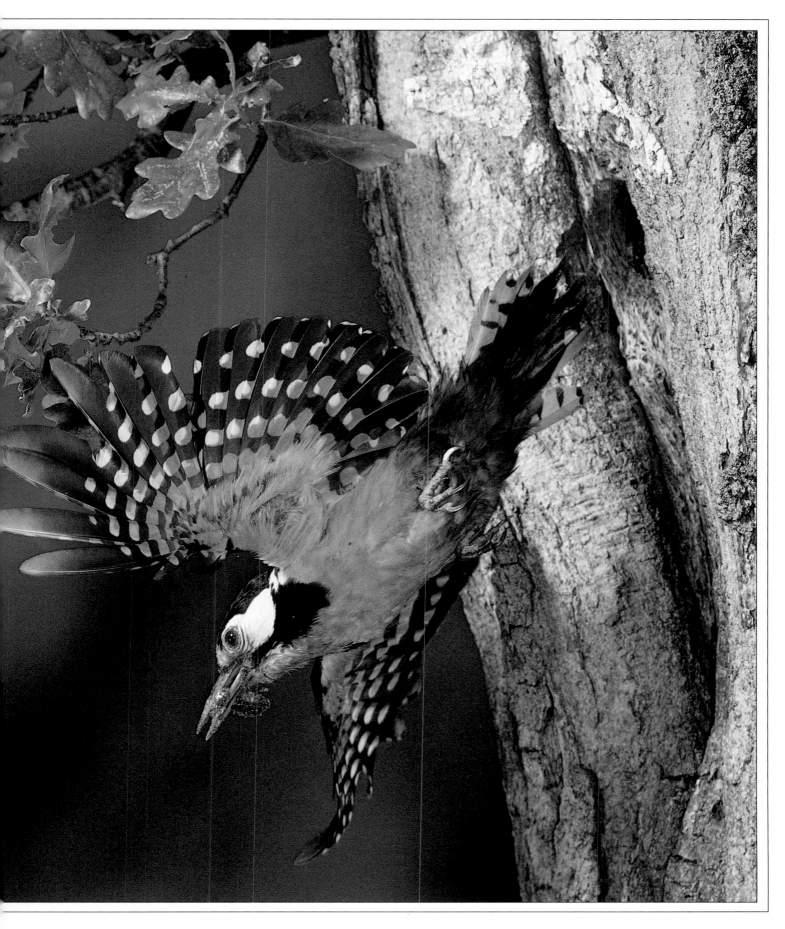

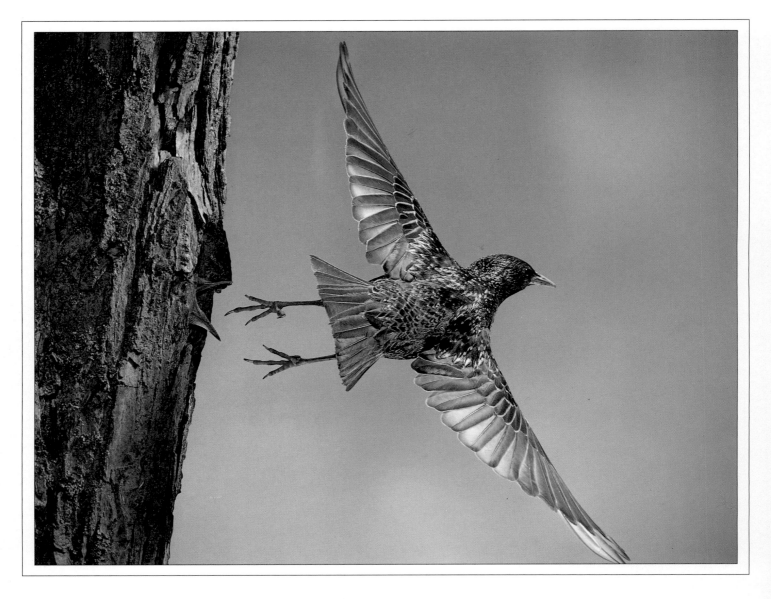

Another bird tackled early on, and one which proved the portability of the new flash equipment (four flash heads had to be supported up a tree) was the **starling** (*Sturnus vulgaris*). Here the propellor action of the wing-tips can clearly be seen as the bird streaks away from its nest hole, having fed its fledglings.

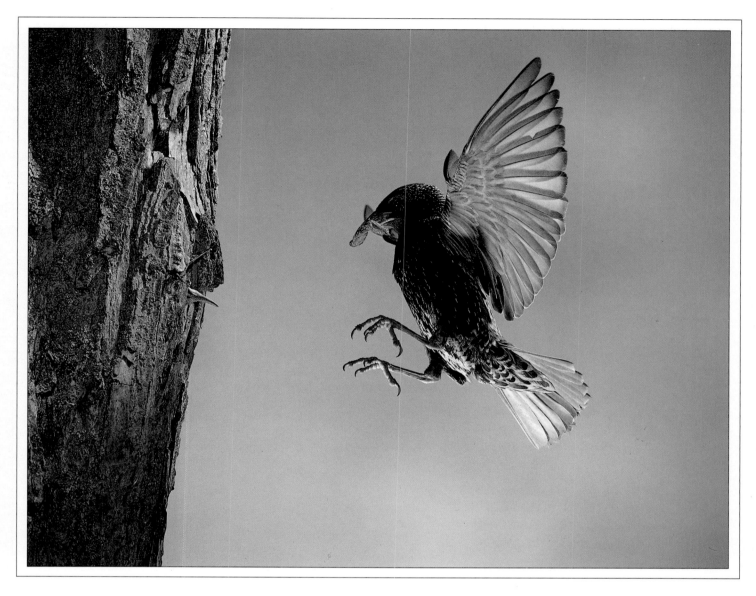

As the bird approaches the tree, *above*, it swings its body into a near-vertical position and spreads its tail to reduce landing speed. Also to reduce speed the *alula*, equivalent to our thumb, is spread forwards from the wings' leading edge.

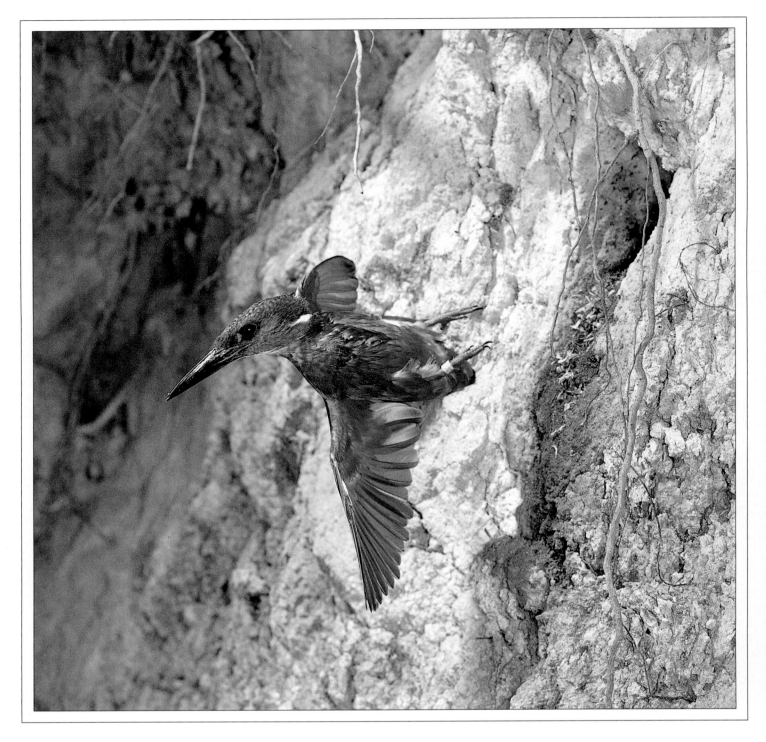

Having just fed its young this **kingfisher** (*Alcedo atthis*) reverses out of its nest hole in the bank of a stream, and deftly executes a 180-degree 'reverse flip' into the air, before diving into the water for a bath. It is interesting to compare this photograph with the kingfisher on page 105, taken in the same stream over ten years later.

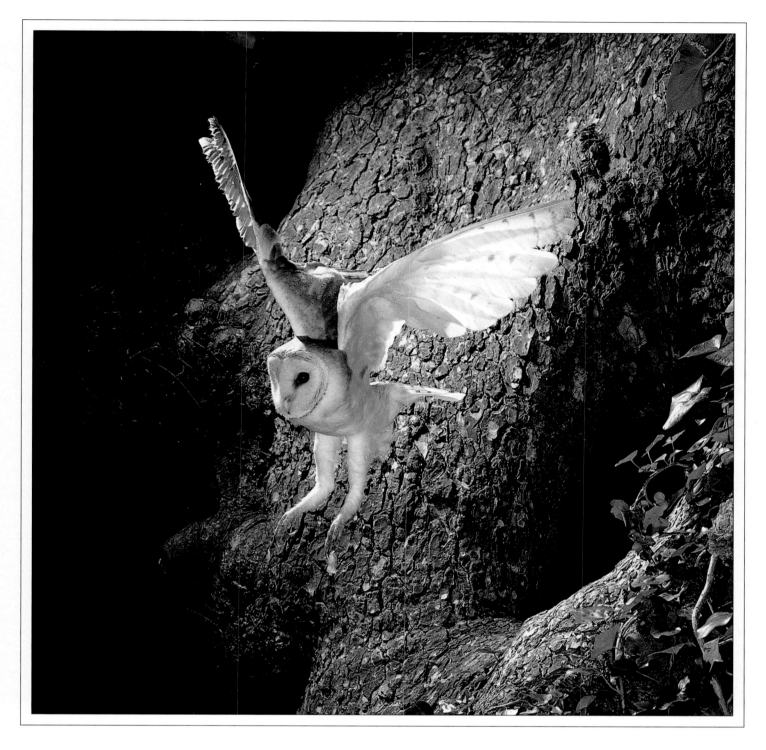

Barn owls (*Tyto alba*) are just as happy resting in hollow trees as in old barns and church towers. Unfortunately though, hollow trees tend to be cut down and old timber barns are replaced by modern corrugated structures while church towers are often sealed up. This, together with loss of habitat due to agricultural developments and toxic chemicals, is largely responsible for the rapid decline of the barn owl population.

These magnificent birds rely on their extraordinary, sensitive ears to locate their prey, hunting close to the ground with a characteristic slow, wavering flight.

The photograph was taken during a severe summer thunderstorm.

A NEW WORLD OF INSECT FLIGHT

1972–77

Common throughout America, the **rhododendron leafhopper** (*Graphocephala coccinea*) was not introduced into England until 1935.

Leafhoppers are extremely active leaping bugs about the size of house flies and, like grasshoppers, have long, powerful hind legs. Their common name, dodgers, was earned through their habit of moving round to the other side of a leaf or twig when alarmed, and peeping out a few moments later to see if all is clear.

Although these creatures use their wings in a conventional manner when moving comparatively long distances, photography demonstrated that they did not open them until several inches after take-off.

In this section we have a small selection of my early colour photographs of insects in free flight, taken during the mid-1970s. Some of them appeared in *Borne on the Wind*, revealing to all for the first time how an insect uses its wings, and how it makes the breathtaking aerial manoeuvres we take for granted. For example, look at the photograph of the brimstone butterfly on page 43, showing the graceful curving of the forewings as they begin their downstroke. Look at the fragile, translucent green wings and soft, thin body of the lacewing on page 47 – it seems the epitome of aerial delicacy. The weak, fluttering flight of these insects appears haphazard and at the mercy of the merest breath of wind, yet this first impression hides a more efficient reality. They are flying machines capable of sensational loops and vertical take-offs, as I finally proved after experimenting with some 900 exposures.

With the new, sharp images, other fascinating characteristics become clear. Consider the spectacular black witch moth from South America on page 52. Whoever could have imagined that it, together with many other species of moth, frequently sheds scales when taking off. Or wonder at the elegant symmetry of the Aeshna dragonfly as it sails through an Everglades forest (page 50). I could finally show just how spellbinding these creatures are in their natural medium.

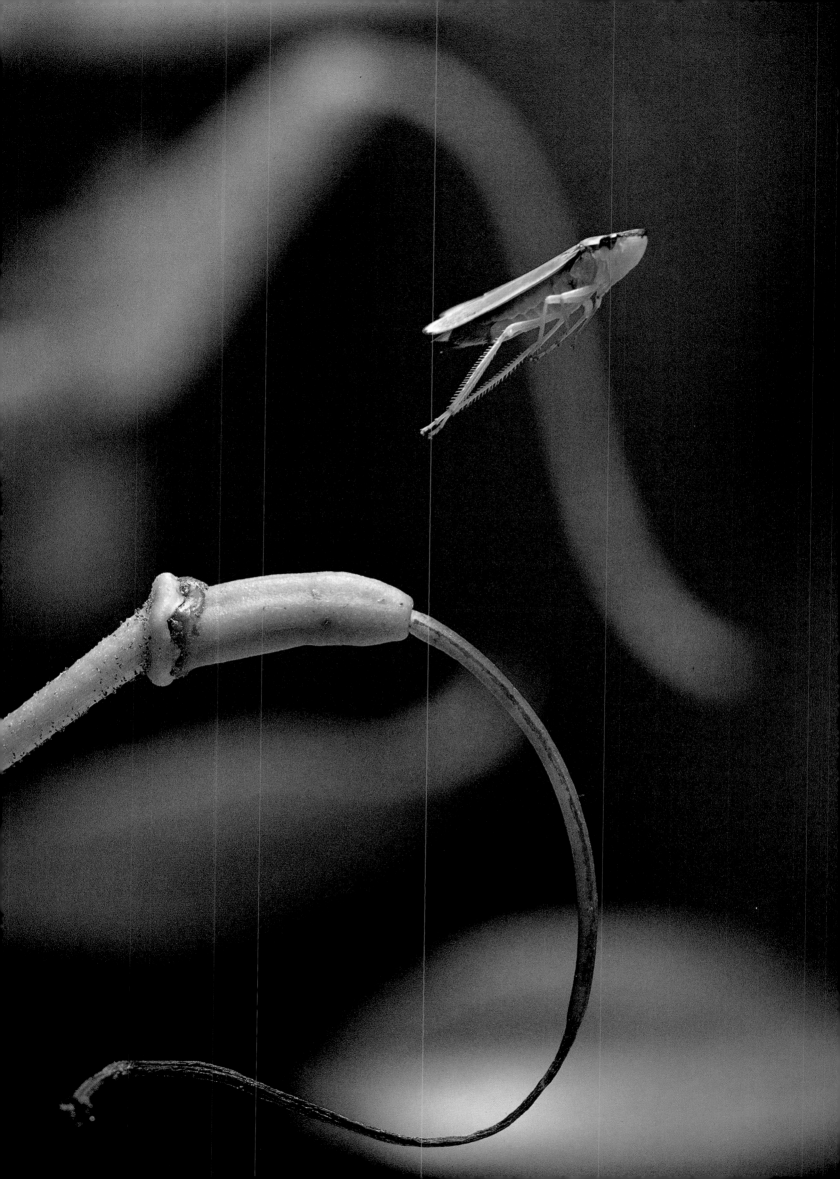

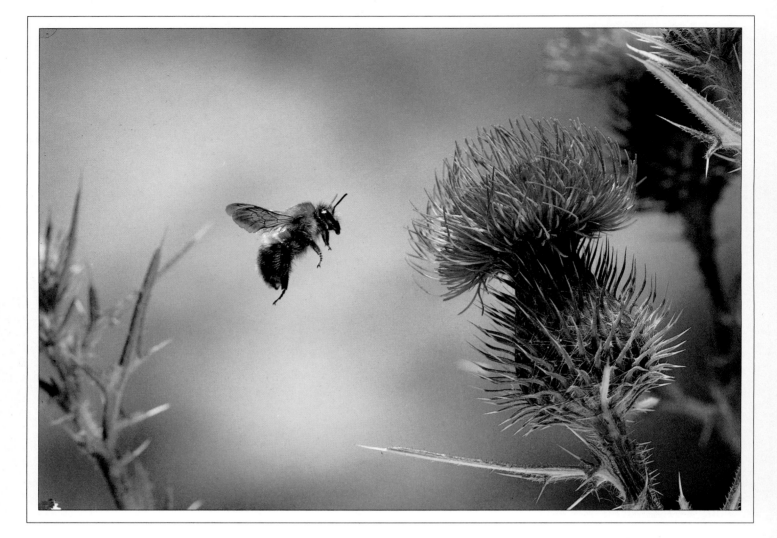

When all other insects have long ceased to fly, it is the **bumblebee** (*Bombus agrorum*) which keeps going, frequently flying on cold, wet and windy days visiting one bloom after another with resolute fortitude.

Before any insect can take to its wings, its body temperature has to be sufficiently high. Thus being 'cold-blooded' means that most insects can only fly in warm weather. However the bumblebee is capable of flight when conditions are only a degree or two above freezing. It achieves this by making use of the metabolic heat generated by its flight muscles, sometimes raising its temperature to as much as 40°C. For such a small creature to generate so much heat requires an enormous expenditure of energy. Even more remarkable is its ability to uncouple the flight muscles from its wings, vibrating and warming them up without actually moving its wings at all.

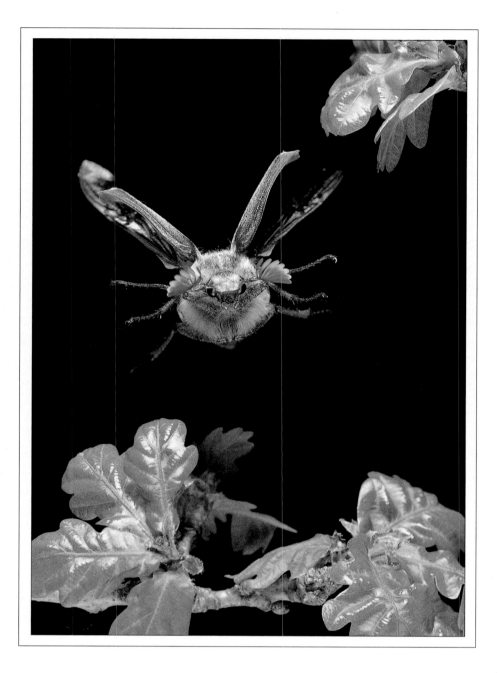

This **cockchafer** or maybug (*Melolontha melolontha*) was one of the first flying insects to be photographed in colour.

The beetle cannot fly until it has filled numerous air sacs in its body. Even then it has difficulty in becoming airborne and is a slow, noisy, clumsy flier. Particularly attracted to lights on warm evenings during early summer, it bangs against windows or, on entering and circling a room, often blunders into objects and falls to the floor.

42

A harbinger of the spring, the sulphur-yellow **brimstone** (*Gonepteryx rhamni*) is one of the first butterflies to be seen on the wing, sometimes as early as February. It was also one of the first flying insects I photographed in colour.

The butterfly shown here is the male, the female being so pale in colour that it can easily be confused with the cabbage white, a close relative. However, the flight of the brimstone is stronger than the cabbage white's erratic fluttering.

The brimstone is one of the longest lived of European butterflies: those emerging from their chrysalis in August often survive until June the following year. Winter is spent in hibernation, the butterflies hiding in thick clumps of ivy or evergreen bushes where their leaf-like wings merge with the surroundings. In April the mating season starts, the males pursuing females along the hedgerows, sometimes flying for miles in quest of a mate.

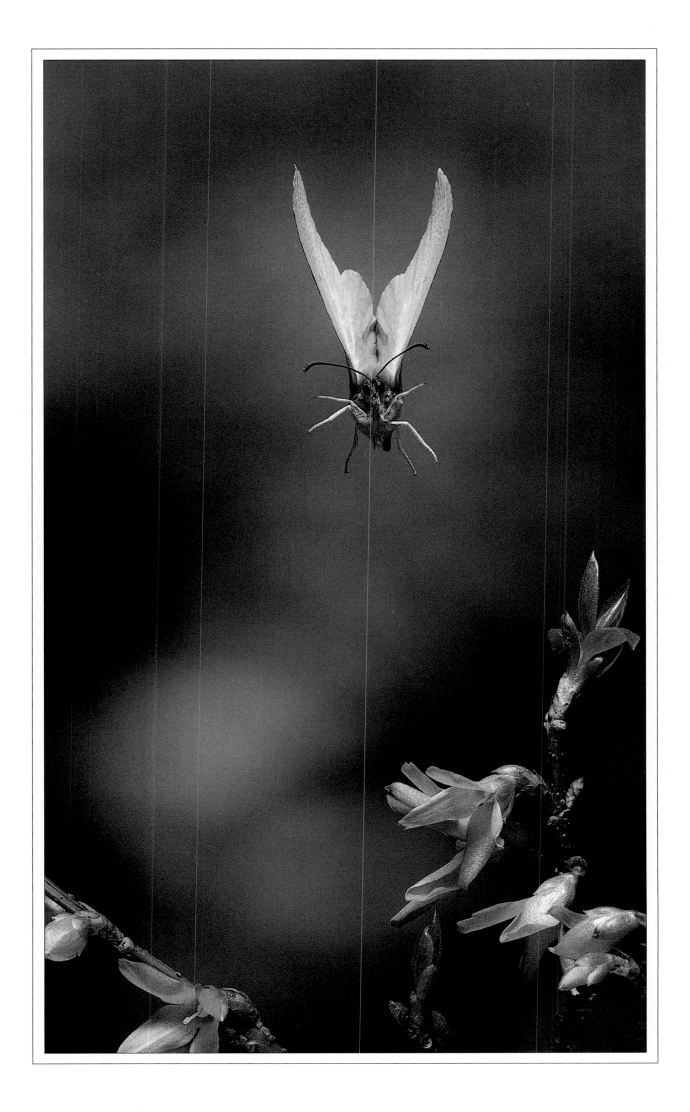

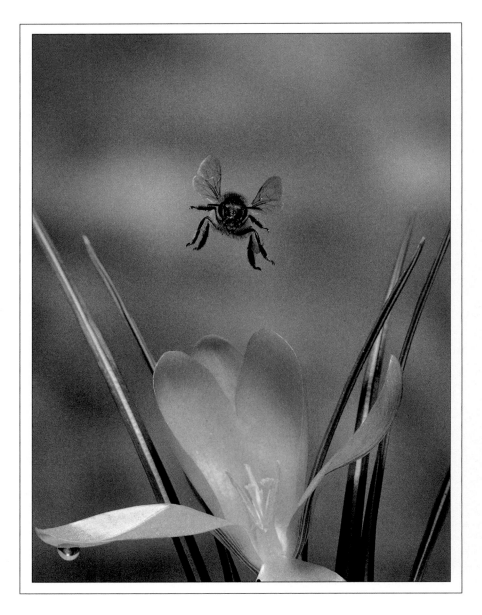

After loading its pollen baskets with pollen collected from a bank of spring crocuses in the garden, this **honeybee** (*Apis mellifera*), *overleaf*, was caught and encouraged to fly through my flight tunnel a few times before being released. As bees cannot fly for long without refuelling, it was fed with a little sugar and water to sustain its flight home.

A **silver-studded blue** (*Plebejus argus*), *opposite*, flits through the air with seeming gay abandon as it makes its way to the exit of my flight tunnel.

All blues are swiftly flying butterflies and most prefer the open meadows and hillsides to woodland areas. This species is generally found on dry heathland, although it can be seen locally on chalkdowns and sandy coasts. Here, a simple background reflects the insect's favourite haunts.

The silver-studded blue is yet another butterfly which is becoming scarcer as each year passes.

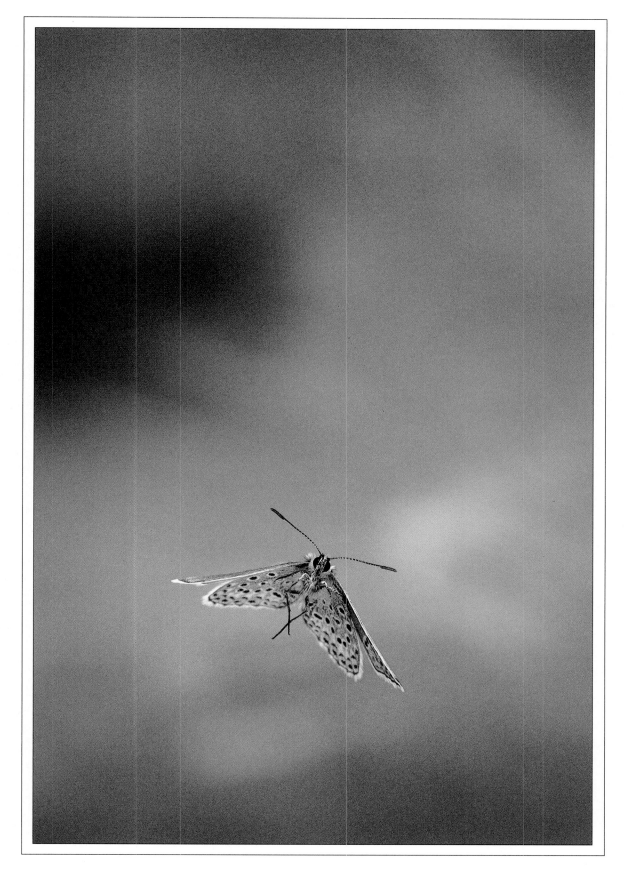

46

The first hint of the phenomenal flying capabilities of these bewitching insects came to me while testing an early version of the multiflash. I was surprised to see that a **green lacewing** (*Chrysopa carnea*) had risen vertically from a hawthorn leaf, with its body perpendicular and its four diaphanous wings arched above like an inside-out umbrella.

Later on, and after making hundreds of exposures, I discovered how incredible the aerial antics of lacewings were. As well as performing vertical take-offs, they frequently did loops or half loops, sometimes landing on the same spot. I wondered whether this was intended to baffle pursuers, or whether it was pure chance – I suspect the former.

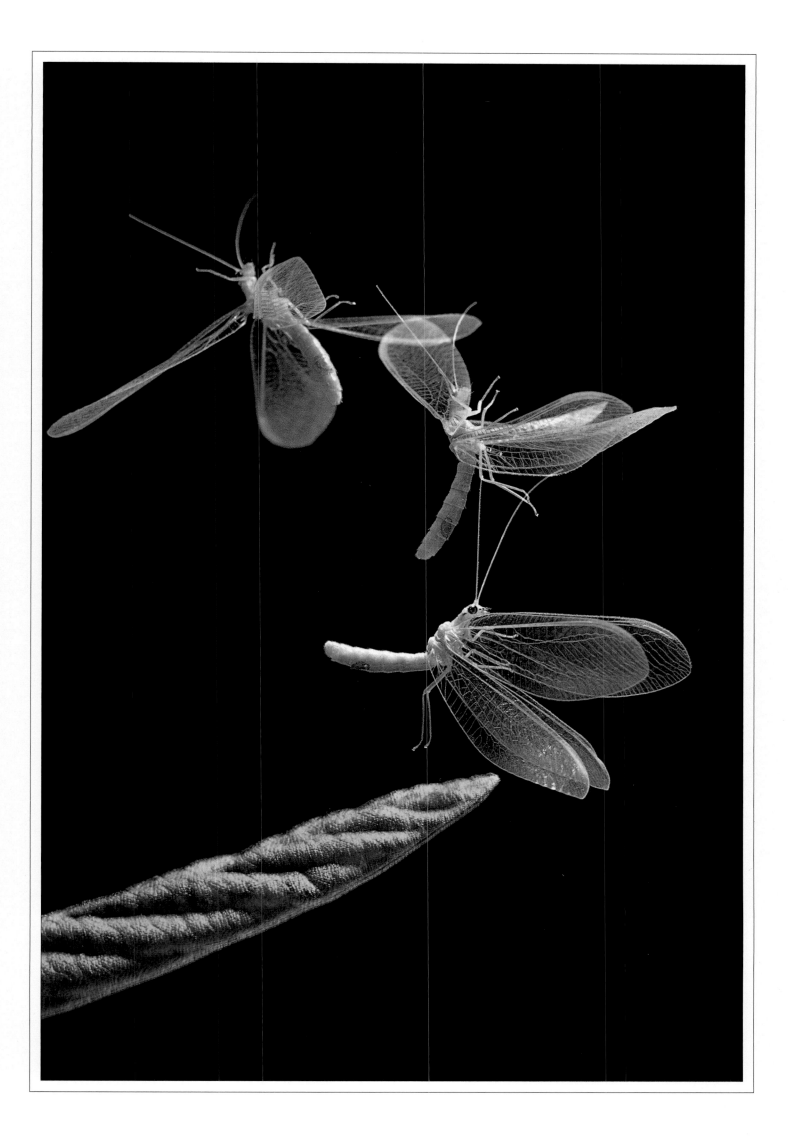

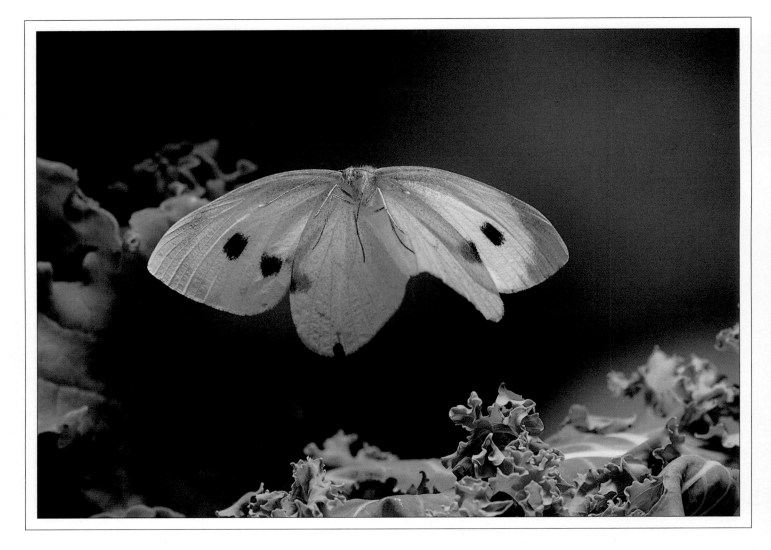

Having just laid her eggs, the notorious **large cabbage white butterfly** (*Pieris brassicae*) innocently flutters over a cabbage leaf. Fortunately, this pest of cabbages and other cruciferous plants is kept under reasonable control naturally by both bacterial disease and the action of parasite wasps, which attack the caterpillars.

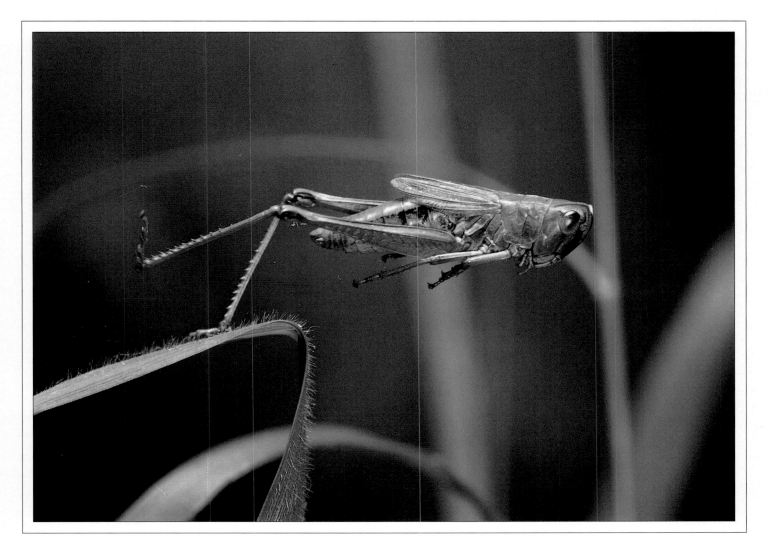

The long, muscular thighs of the **short-horned grasshopper** (Family *Acrididae*) are so powerful that a 1/20,000th of a second flash fails totally to freeze the movement at the moment of take-off.

The majority of short-horned grasshoppers are active during the day, have well-developed wings and can fly. The males 'sing' by rubbing the inside of their peg-studded hind-leg against the thickened veins on the forewings.

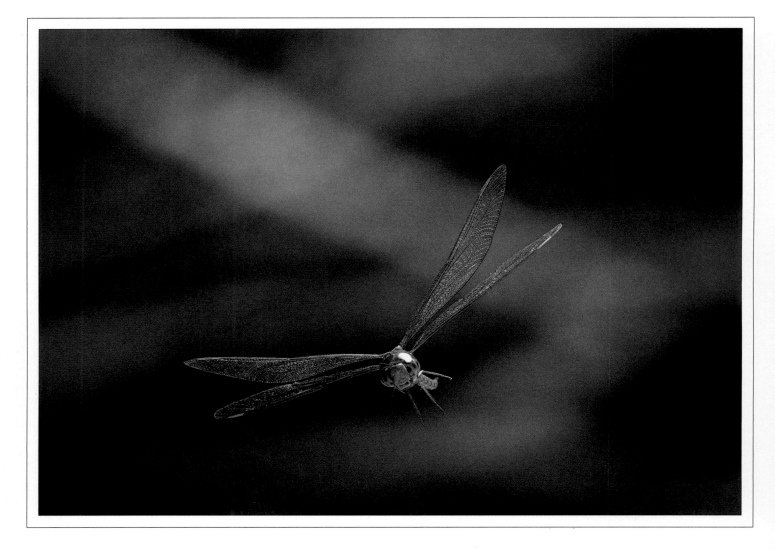

The evening I came across these large **hawker dragonflies** (*Aeshna* sp.) was a memorable one. I was in the Everglades National Park in Florida wandering though a small pine forest. As dusk approached these beautiful creatures seemed to appear from nowhere and began a steady patrol of the woodland rides, hunting mosquitoes. At times they would fly only a few feet off the ground, their thin chocolate-brown bodies and amber-tinted wings merging with the gloom of twilight, only the faintest rustling in the still air betraying their presence. In the fading light, now silhouetted against the darkening sky, they flew higher and higher, following the rising mosquitoes, dodging the gigantic webs of the golden orb spider and weaving between the branches of the tall pines.

As I was working on my first book on insect flight at that time, I returned to the same spot the following day and netted a specimen. When the photography was completed, the insect was returned unharmed to its favourite haunt.

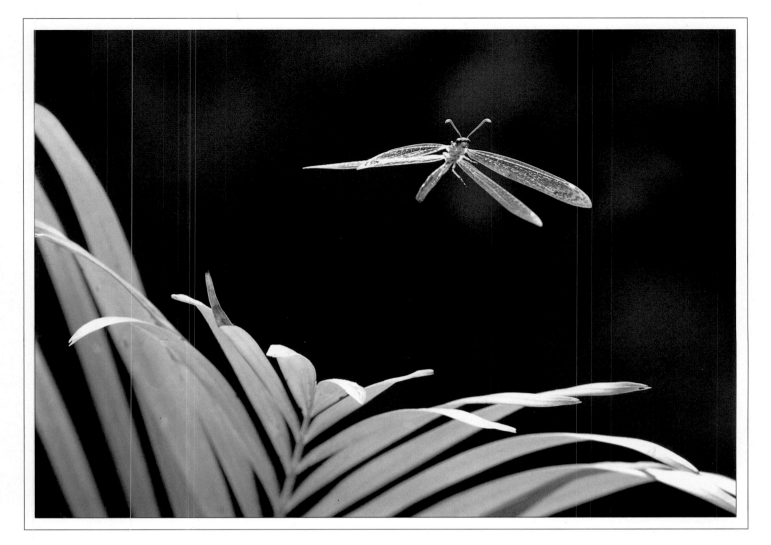

The elegant and weak flight of an **antlion** (Family *Myrmeleontidae*) is captured as the insect sails over a tropical palm leaf. However the insect's charm belies its earlier larval existance, when it ensnares hapless ants by making a trap in the form of a deep conical pit of sand, where it waits in ambush, buried out of sight at the bottom.

Antlions are closely related to our more familiar lacewing flies.

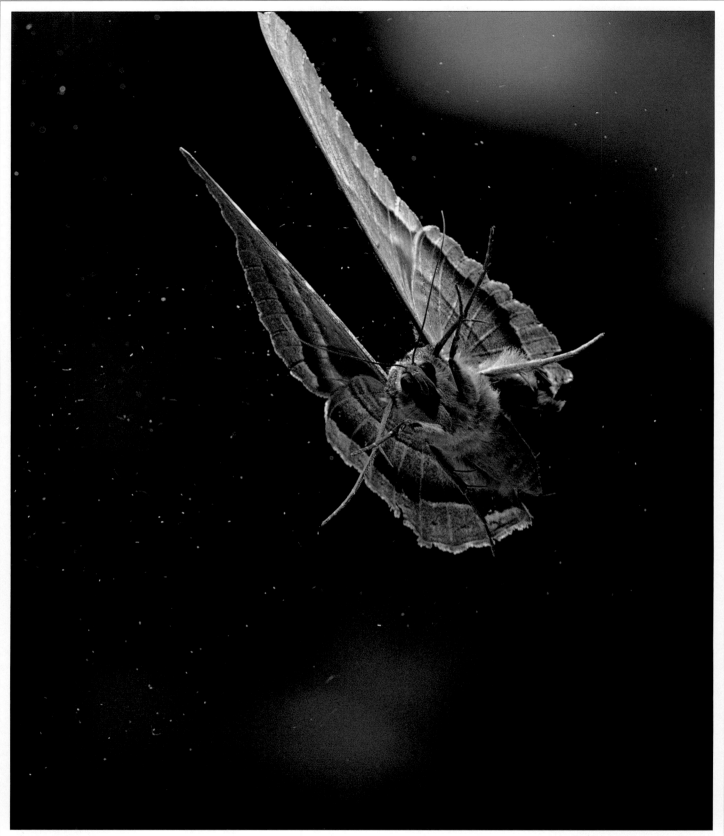

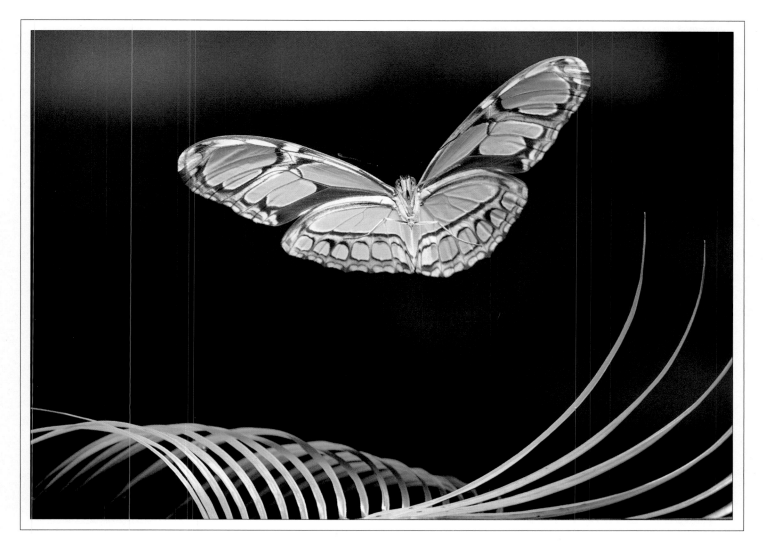

Another of the countless spectacular insects from Venezuelan cloud forests is the **black witch moth** (*Ascalapha odorata*), *left.* With a wingspan of some eight inches (20 centimetres) this moth belongs to the same family as our modestly-proportioned noctuids or owlets – the often dull brown or grey moths which enter our houses. The pale specks are wing scales which have been shed during the frenzied activity of take-off.

It is unthinkable that the most complex, beautiful and important of habitats, rainforests, are as the result of man's insatiable greed, being destroyed with an accelerating ferocity, current estimates being some fifty acres per minute.

The first time I ventured into a tropical rainforest remains indelibly imprinted on my memory. My senses were saturated by the sights, sounds and scents of the bewildering abundance of life around – an experience no words can begin to convey. All I have done here is to isolate in visual terms only a moment in the lives of three insects from a Venezuelan rainforest.

Among the most exquisite butterflies to be seen was the **green heliconid** (*Phylaethria dido*), *above*, with its delicate shades of green and silver. But no amount of refined photography and subtle lighting can do the living insect justice.

NEW SUBJECTS FOR SPEED

1978–84

After the challenge of insects, it was natural that I should be keen to capture the movements of other rapidly-moving animals. If it was possible to freeze insect flight then other things should be simple – in theory at least. Although most of the subjects in this section took days or even weeks of work, a few, such as the wren on page 60, were photographed in a single day.

One of the most successful pictures included is that of the swallow on page 61. The project went on for over five weeks, starting after I watched these lovely birds dipping into our fishpond. Sometimes they appeared to brush the surface with their beaks and occasionally they struck the water with an impressive splash. Were they drinking, bathing or collecting insects? High-speed photography should provide the answer, but clearly the operation would be hard to do well. Somehow, without frightening them off, I had to persuade the birds to strike the water regularly at the precise point where my camera was to be focused.

In order to confine the splashdown most of the pond had to be masked with wire netting. To avoid upsetting the birds this was done gradually over a week or two. Then, bit by bit, I introduced the photographic hardware, moving it closer each day. The lights were arranged to eliminate any trace of 'flashiness' so the photograph looked as though it had been taken by natural daylight.

Before the photography could start, the noisy motorized camera needed to be silenced. Finally, everything worked perfectly and the swallows seemed completely at ease. Now I could see what the birds were really doing. Usually they approached the pond from a low angle, skimming over the surface and scooping water into their beaks. Less often, the approach path was much steeper and the bird would dive with wings folded for a bathe, to emerge a second later like an aquatic jack-in-the-box.

Hummingbirds are some of the richest gifts to the avian world. Their diminutive size and iridescent colours, combined with their breathtaking performance on the wing, place them in a class of their own. To stay alive they must visit thousands of blooms each day to extract sufficient nectar, while at night many of the smaller species go into hibernation to save energy, lowering their metabolism to about one-fifteenth of its daytime value.

This photograph of the **violet-cheeked hummingbird** (*Colibri thalassinus*) was specially taken for a front cover of a book about pollination. To evoke the feeling of hovering a relatively slow flash speed was used.

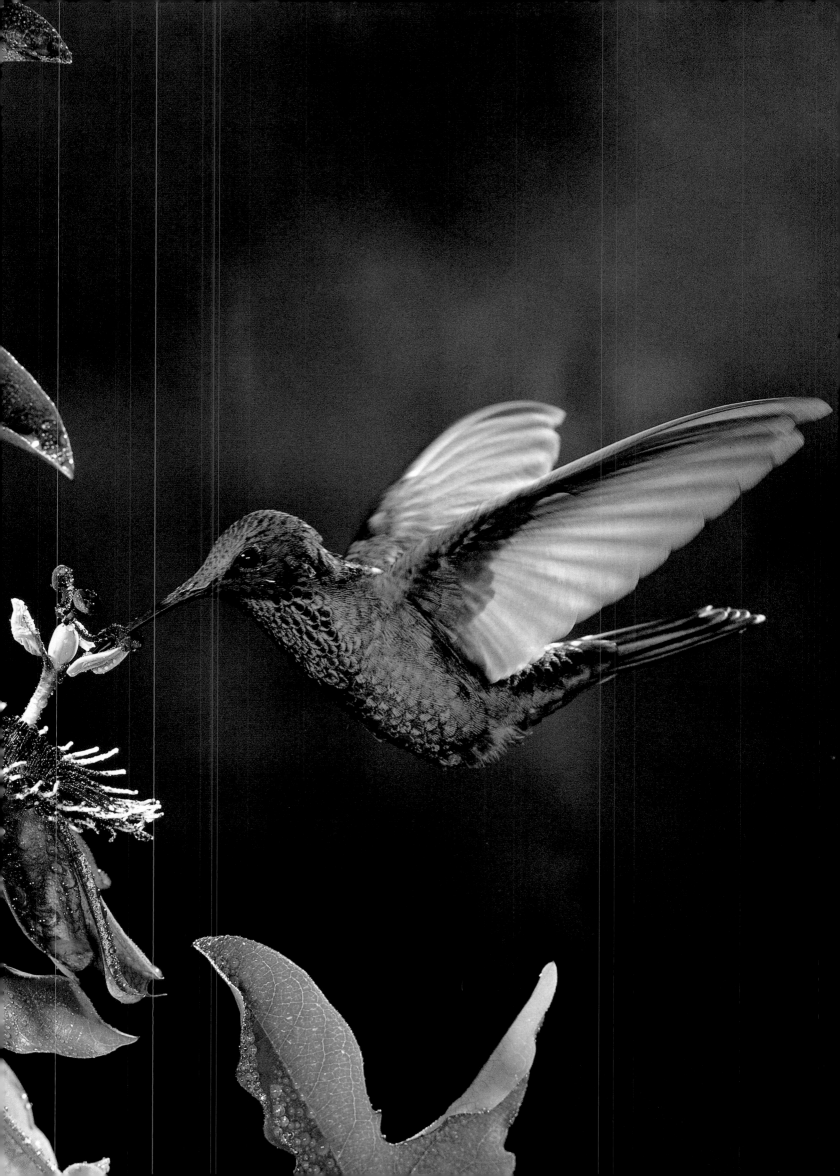

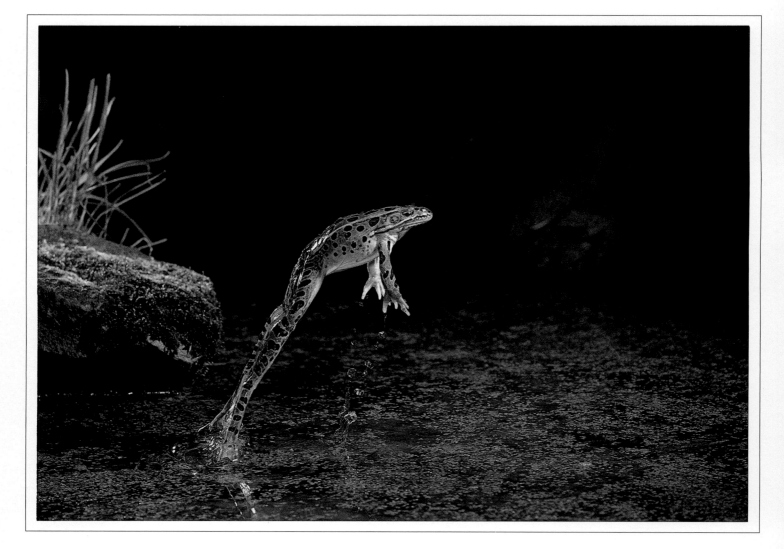

The **leopard frog** (*Rana pipiens*), *above*, is the 'common frog' of North America and is a much more enthusiastic leaper than the European species, as these pictures will testify. Here, a frog has just vacated the shallows for the security of deeper water.

Frogs often spend much of their time sitting on the bank of a pond or stream, *right*, but if danger threatens they dive into the safety of the water where they are better equipped to escape.

The **western diamond-back rattlesnake** (*Crotalis atrox*), *overleaf*, may seem distasteful to some, but it is honed to perfection for the special life it leads. Even its graceful shape and flowing movements lend the snake a certain charm.

Most snakes are reluctant to bite humans unless severely provoked. In my efforts to show the action of a snake striking, one European viper, two puff-adders and a pair of rattlesnakes were employed, so rarely did one strike. But on the odd occasion the reptile did so, the speed was phenomenal.

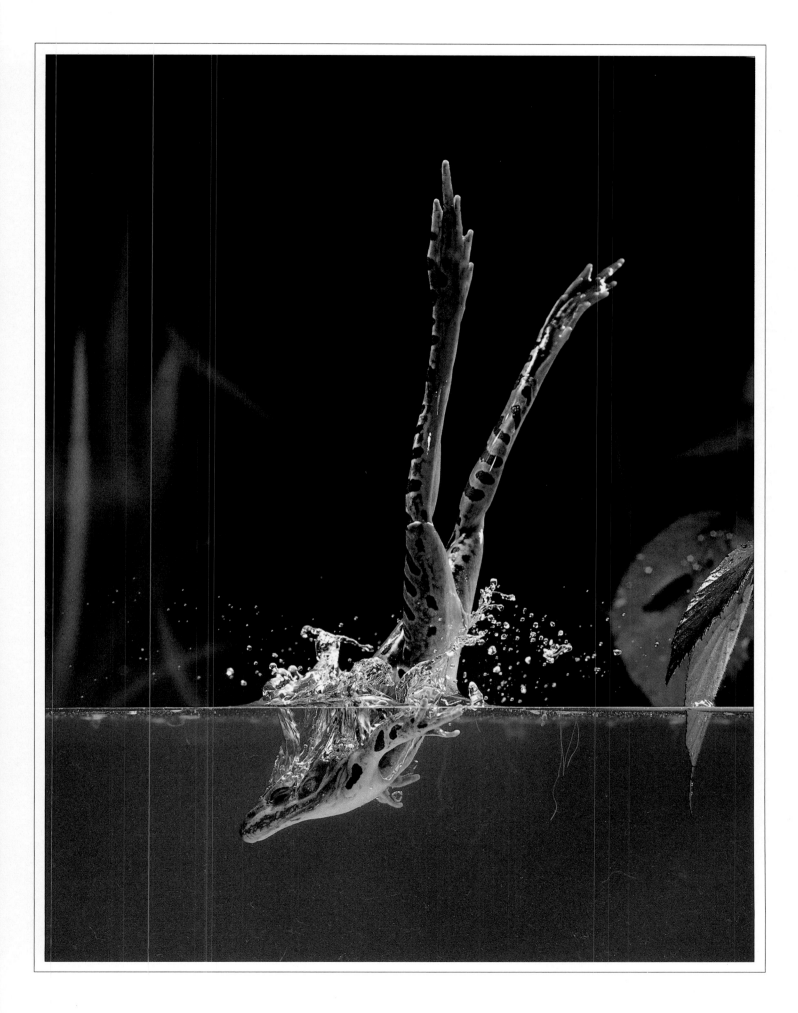

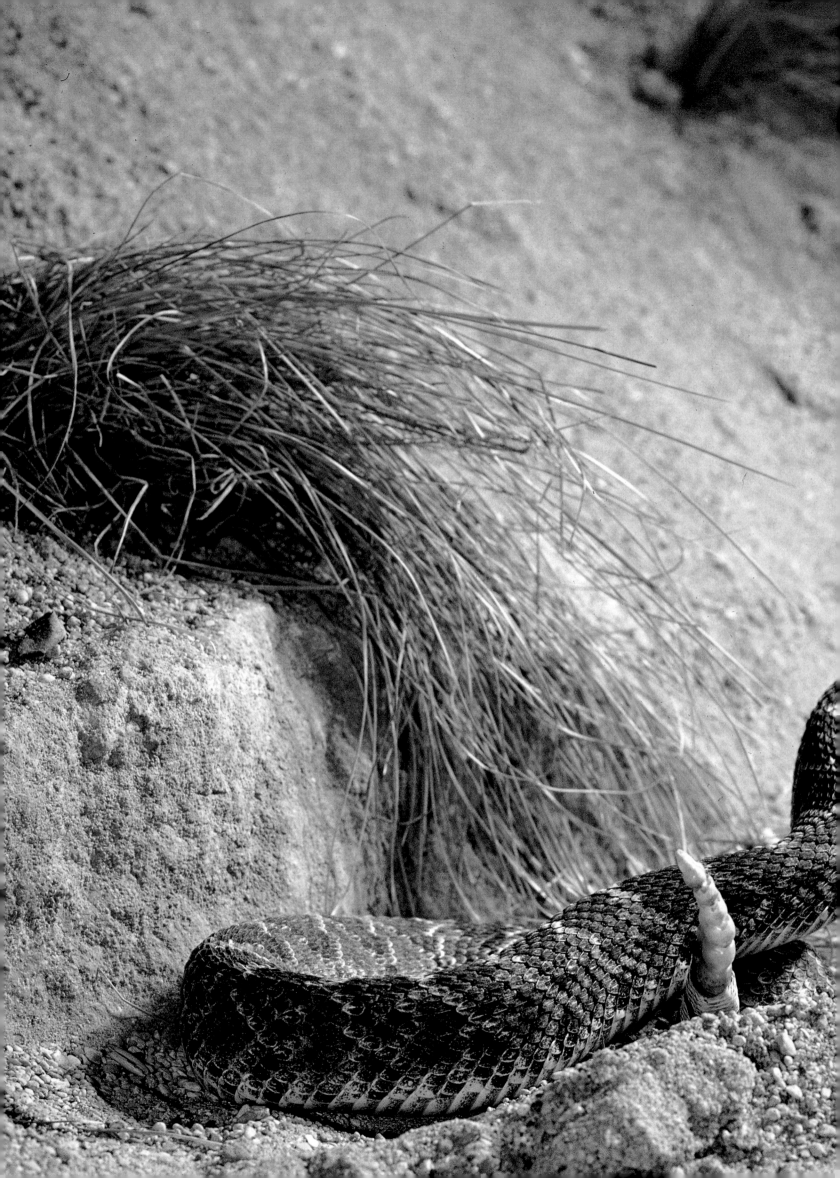

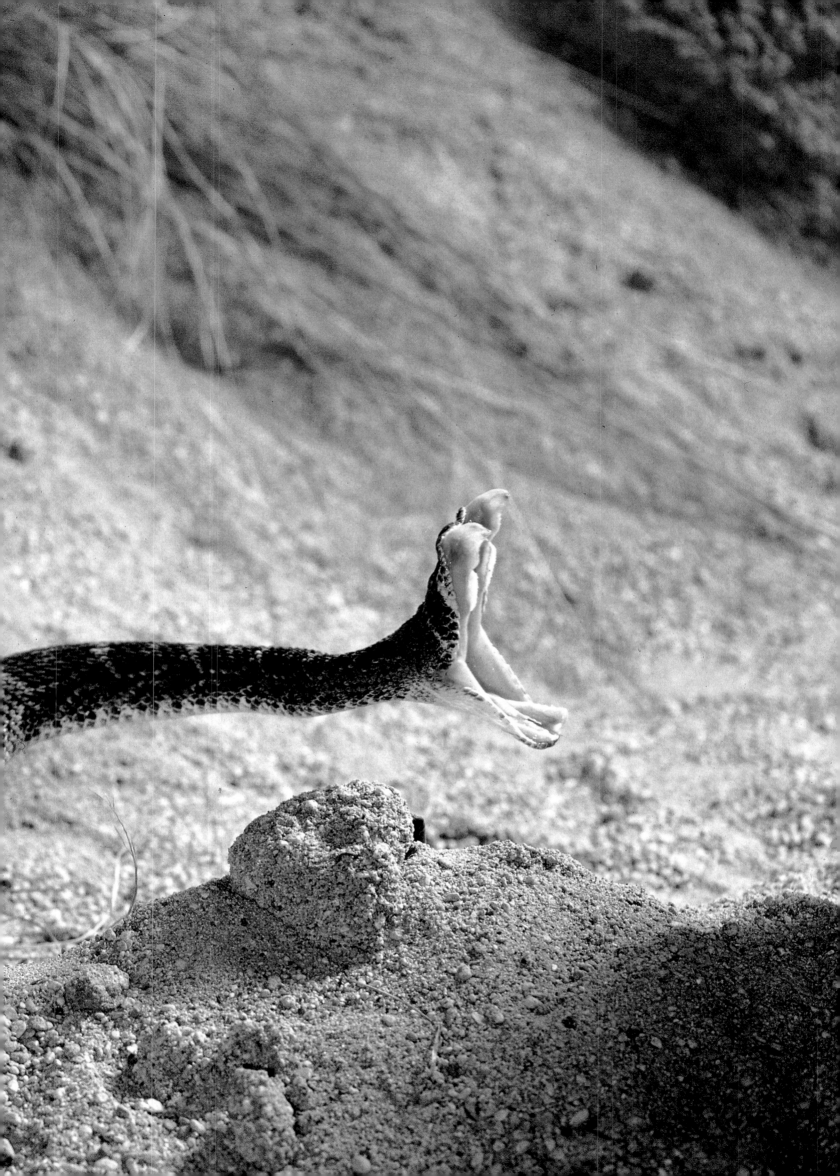

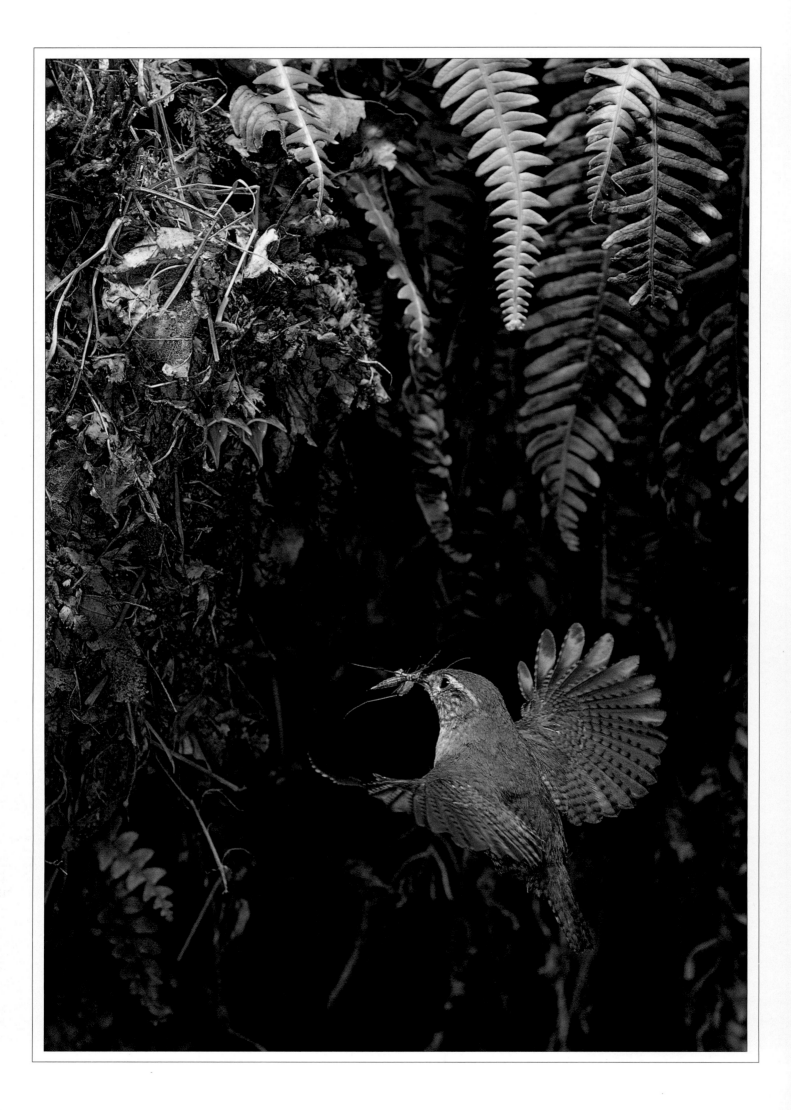

This **wren** (*Troglodytes troglodytes*) is carrying a crane-fly (*Tipula* sp.) to its young, *left*, which are seen poking their heads out of the beautifully camouflaged domed nest.

These little birds may be found almost anywhere, from woodlands and reed beds to moors and rocky islands. The wren also sings at any time during the year, the bird appearing to tremble with passion as it delivers its shrill, forceful song.

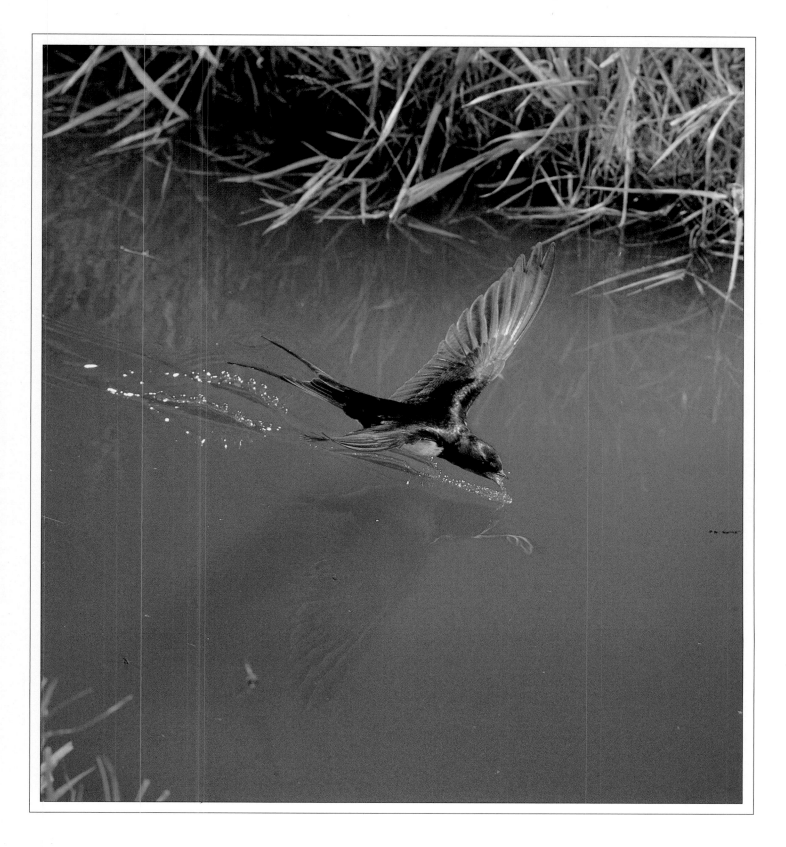

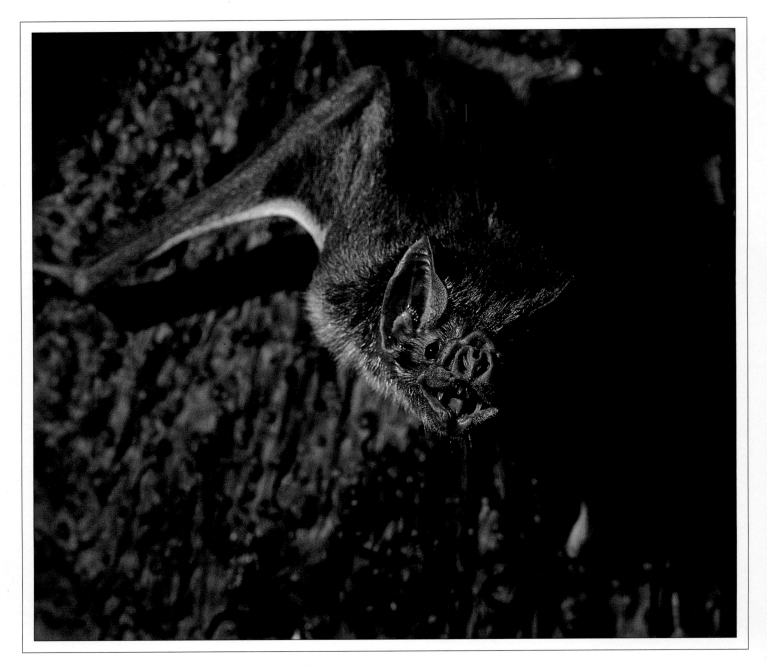

In spite of my love for bats, I could not resist the temptation to portray this **vampire bat** (*Desmodus rotundus*) in a macabre light. Several memorable nights were spent working with these intriguing creatures in the wilds of Venezuela actually photographing them 'attacking' their victims. Contrary to popular belief they do not inflict a gaping wound or suck blood, but, after making a small neat incision with their razor-sharp teeth, delicately lap the flowing liquid.

I always love to watch swallows or swifts on the wing, so when a pair of **swallows** (*Hirundo rustica*), *previous page*, began regularly to dip into my garden pond, I decided to try recording the action on film. Little did I realize that the whole operation would take five weeks to complete. Although exposed with high-speed flash, the lighting was very carefully arranged to simulate natural daylight.

The final series of pictures not only revealed how swallows drank on the wing, but also how they bathed.

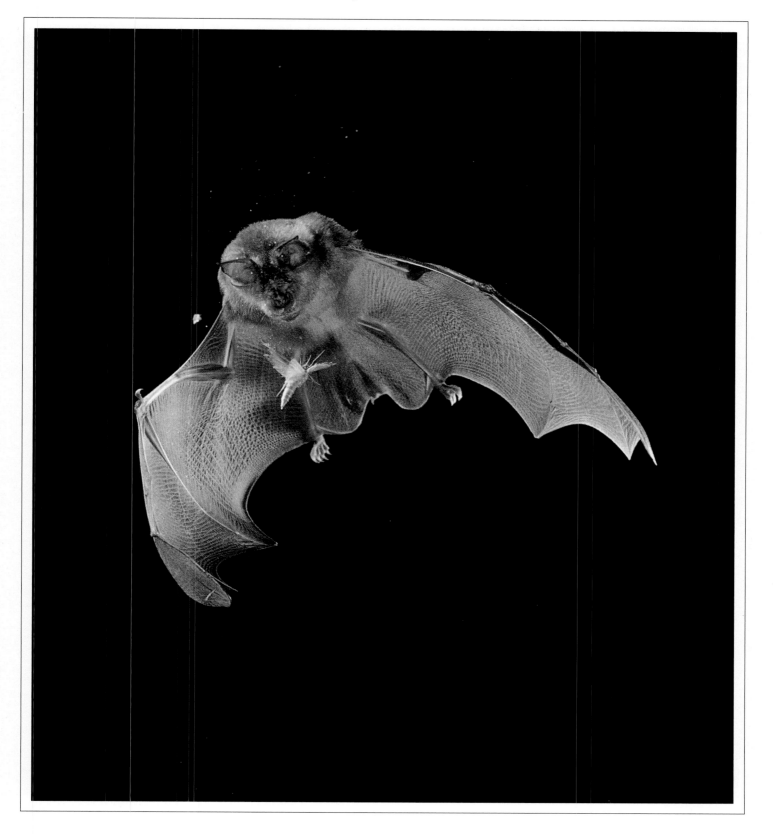

Out of all the animals with which I have worked, the bats are perhaps the most fascinating and endearing. These much-maligned animals, as well as having unbelievably sophisticated navigational skills in total darkness, can be real characters. To photograph their spectacular on-the-wing hunting techniques, I almost lived with this **horseshoe bat** (*Rhinolophus ferrum equinum*) for ten days, so that by the time the task was complete, I was quite sorry to part company.

This picture of a **tree frog** (*Hyla arboria*), resting during the heat of the day on the outskirts of a South American rainforest, was taken with the help of two hand-held flashlights. A photograph like this which only took a minute or two to produce can occasionally be just as effective as a complicated set-up requiring weeks of hard work.

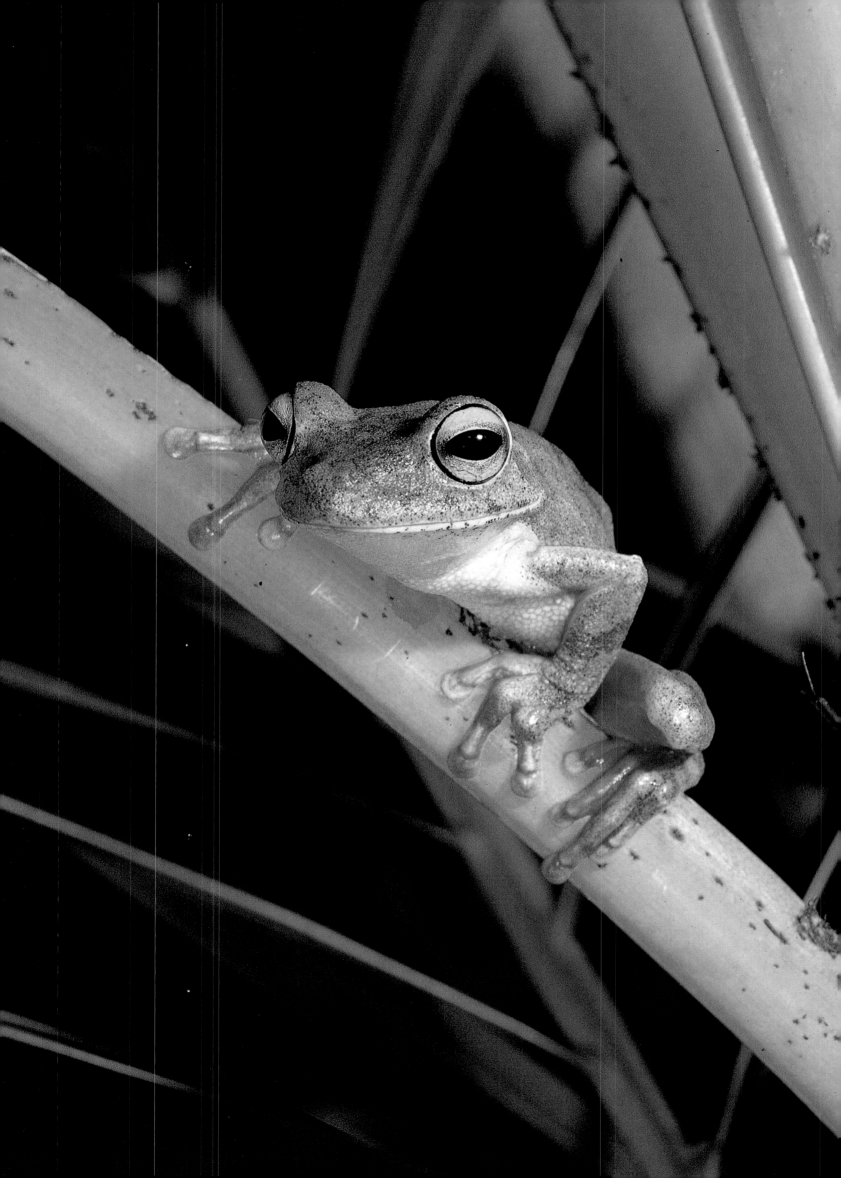

Although rats, when present in large numbers, can be a nuisance and may spread disease, they are great characters as individuals and make lovable pets.

The rat project was a self-appointed assignment and to effect some of the photography I was compelled to keep a number of **brown rats** (*Rattus norvegicus*) at home. Before long, the whole family was totally captivated by their endearing qualities.

Rats have the reputation of being dirty, smelly animals, but this is quite untrue. This individual leaping out of the dustbin (Ratty was her name) hated the filth and stink of the rubbish and could not wait to jump out and get back into her cage.

When Ratty eventually died, there was not a dry eye in the house.

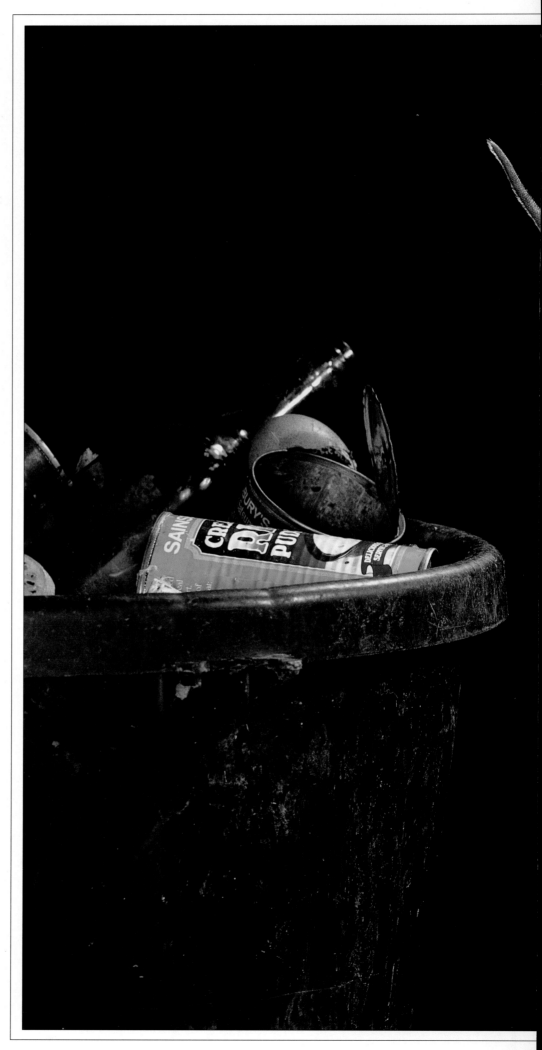

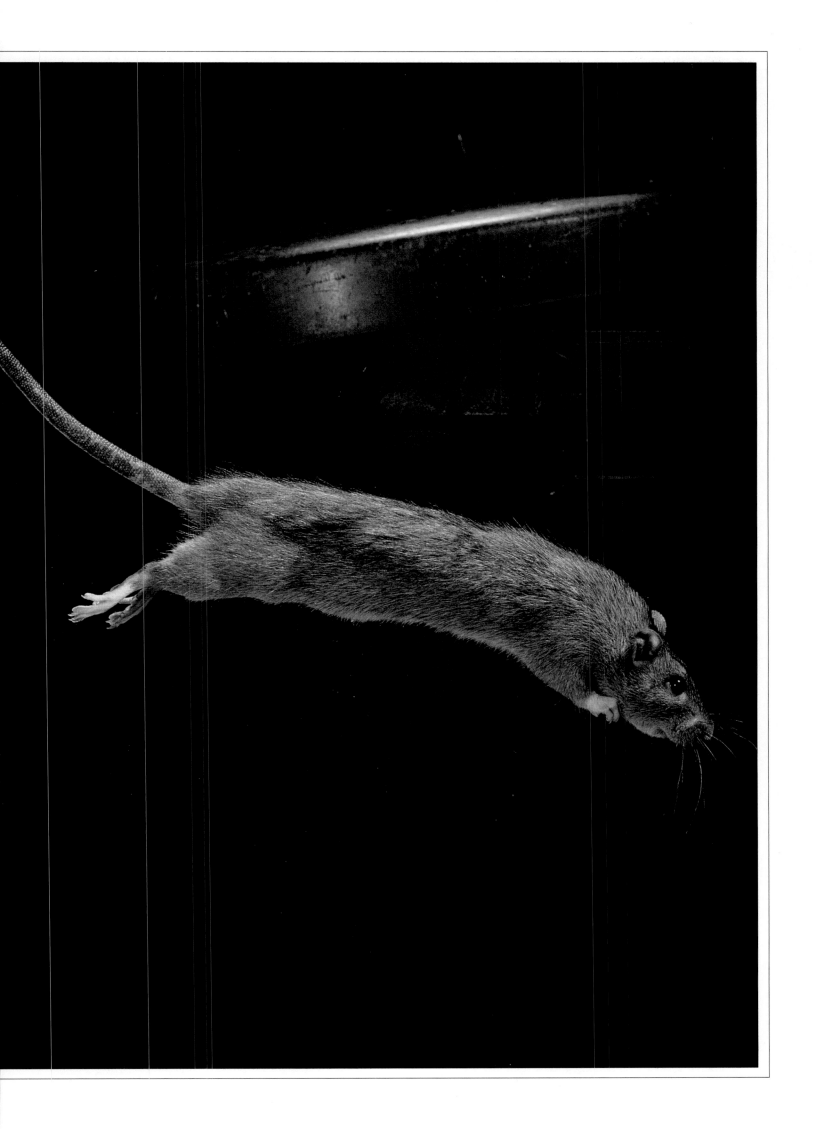

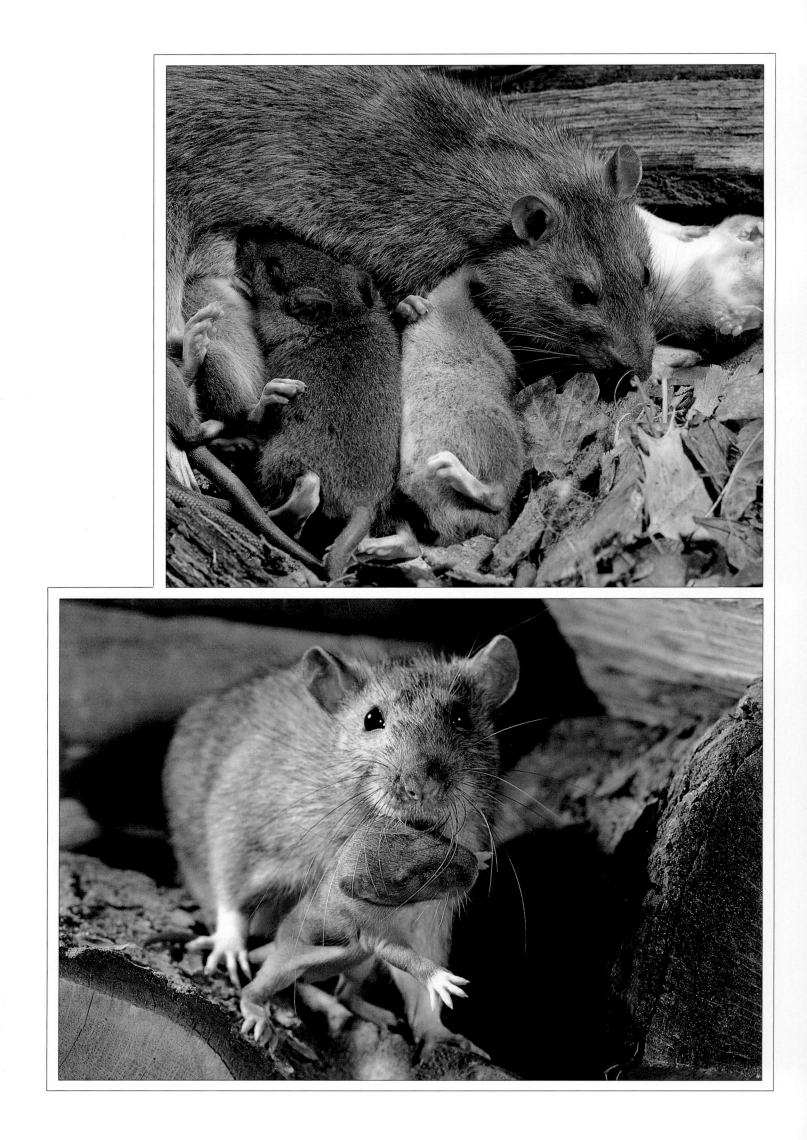

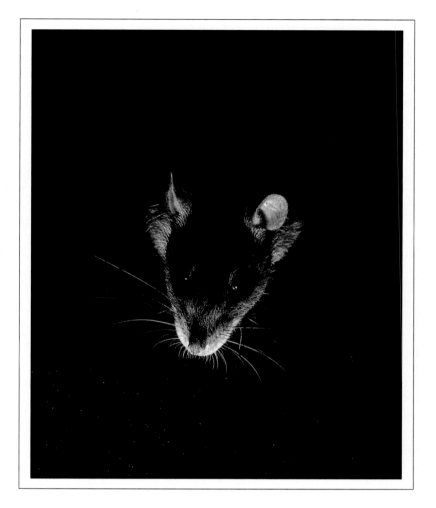

There was much excitement in the household when Ratty became pregnant and gave birth to eleven ratlets in an inside log store, *left.* She proved a wonderful mother, caring for and suckling her offspring without a hitch, and would even allow us to handle her young. If an adventurous youngster wandered too far from the rest, she would retrieve the truant in her mouth.

A somewhat unflattering portrait of Ratty, *above.*

OAK WOODLAND

1985

I have always loved oakwoods. They are quiet places away from the more obvious signs of human activity and I find them places of great spiritual renewal.

Oakwoods also contain a greater number and wider variety of plants and animals than any other habitat. Thus when my publisher suggested that I might do a book on the subject the offer was accepted with alacrity. This was in spite of the fact that I was only given a year to complete the project, and my experience in photographing inanimate subjects such as plants and landscapes was limited.

The main object was to evoke some of the atmosphere of the oakwood and to show its seasonal cycle of life. To do most of the photography I chose an area of woodland surrounding an attractive and natural-looking reservoir near my home in Sussex. Although many of the trees were oak, there were also birch, beech, chestnut and a healthy undergrowth of hazel and other plants.

The wealth of animal and plant life was further enhanced by the three-quarter-mile long stretch of water and the numerous streams and boggy places within its boundaries. Many pleasant hours were spent wandering around, looking for suitable material – flowers, fungi and woodland debris. Such subjects need little planning, involving one in a very low-key and relaxed approach to nature photography. In fact, it is quite easy to drift about for a whole day without taking a single picture! However, more ambitious shots, such as that of the badger on page 77, can involve an enormous amount of time and frustration, as described in the introduction.

This verdant little **oak seedling** (*Quercus robur*) somehow epitomizes the magic of spring, a season of vitality and hope.

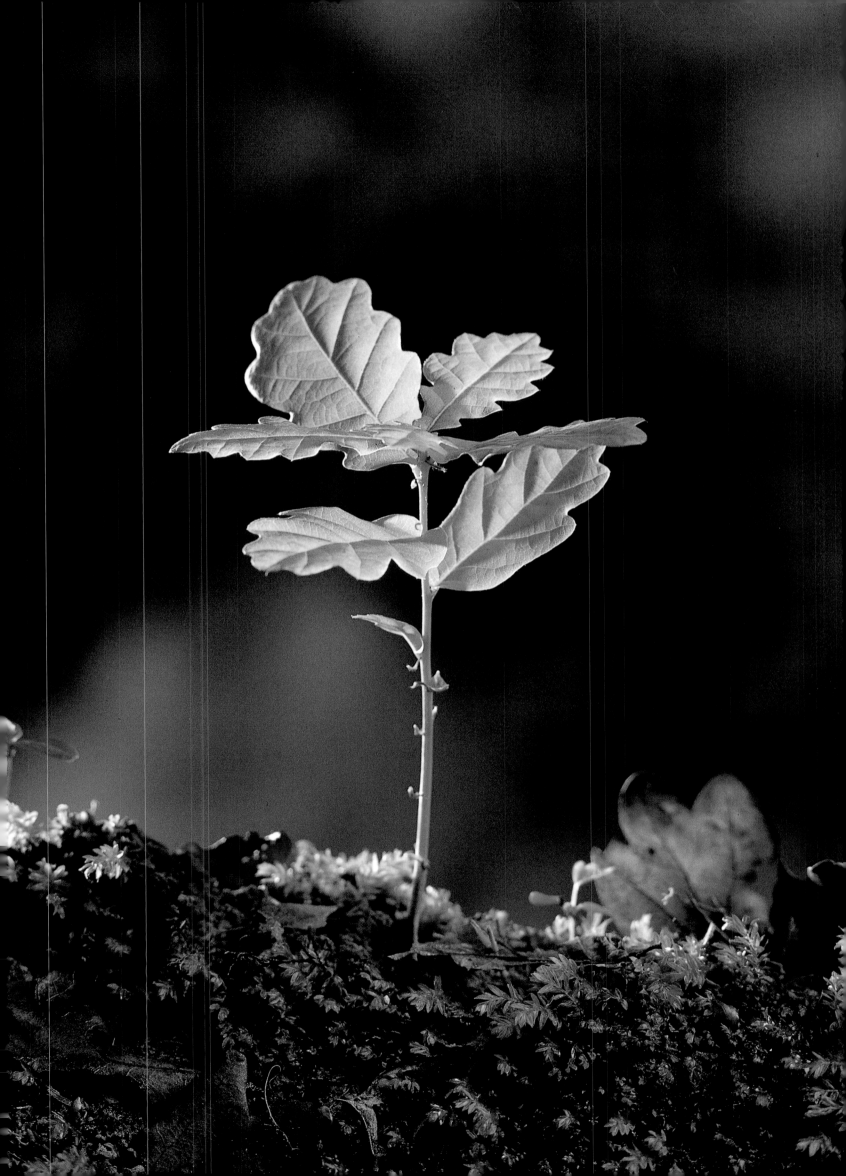

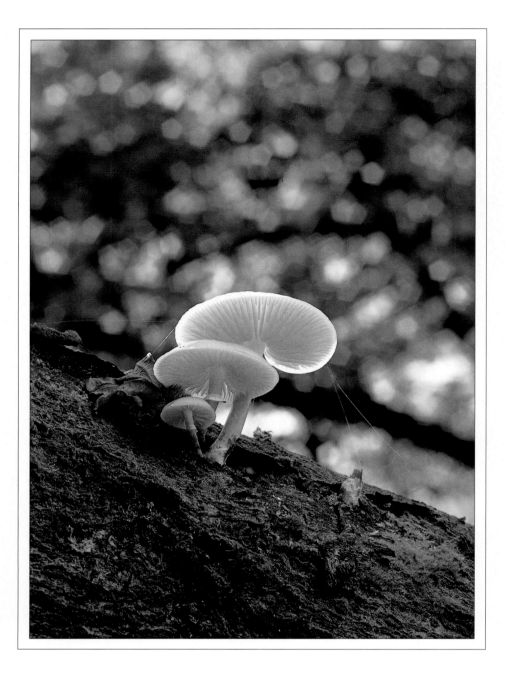

Oaks may support a greater variety of wildlife than any other European tree, but the **beech** (*Fagus sylvatica*) is arguably the most majestic. The vast but beautifully contoured limbs, the massive, smooth trunk and the fresh green foliage give the beech a stature few other trees can match.

Oak woods together with mixed oak and beechwoods sustain a very rich variety of fungi. The highly glazed and fragile-looking **porcelain fungus** (*Oudemansiella mucida*) can be found high up on the trunks of beech trees during late summer and autumn.

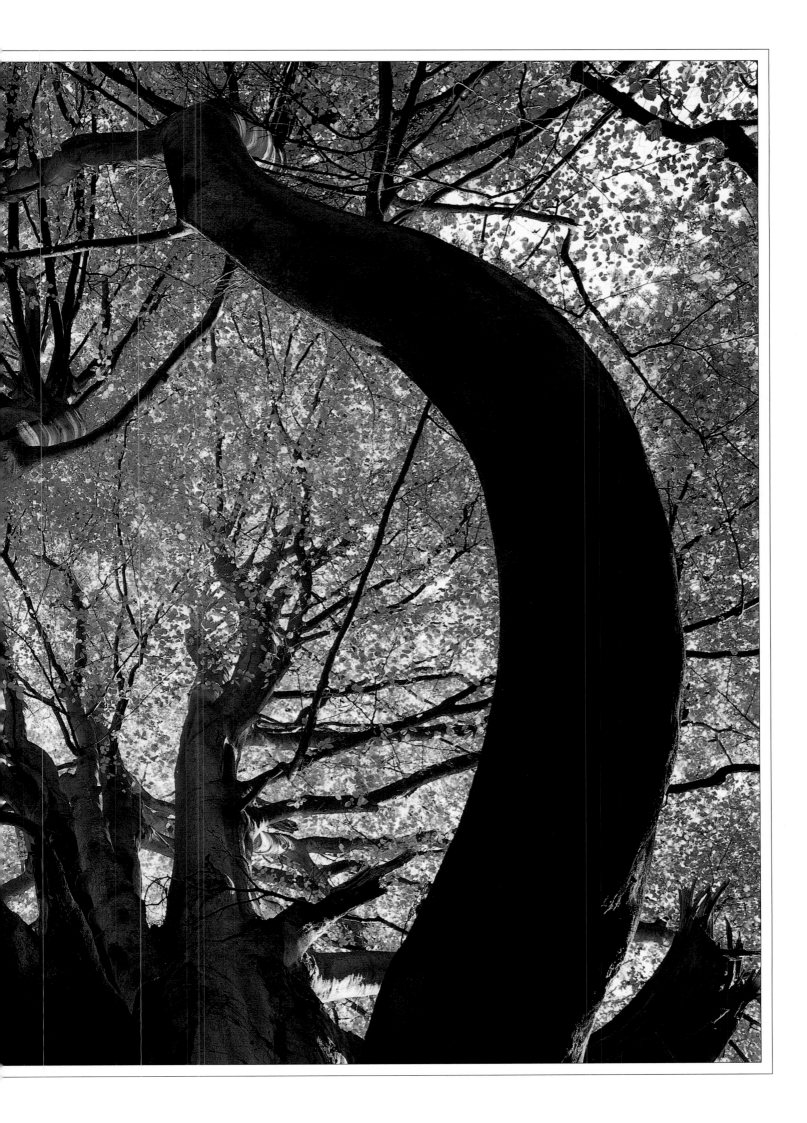

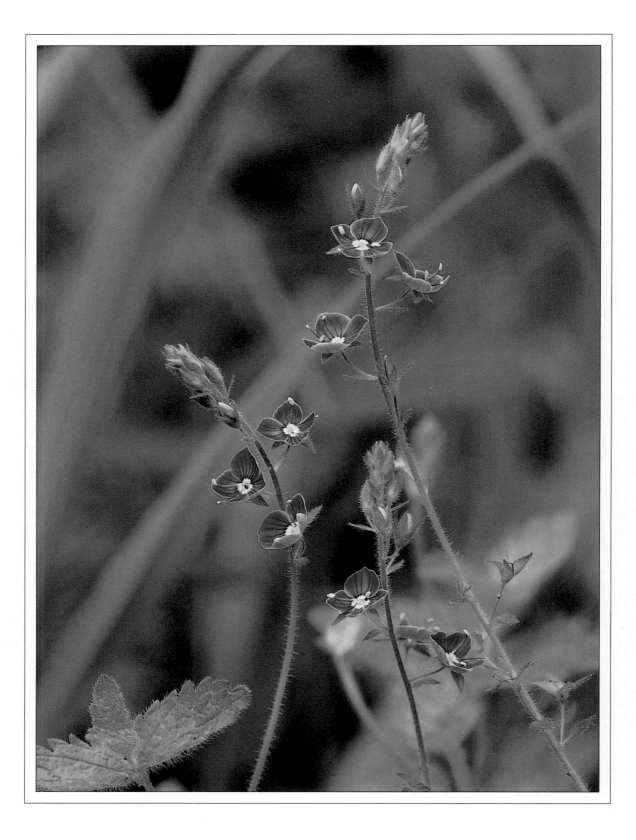

The little blue flowers of the delicate-looking germander or **birds-eye speedwell** (*Veronica chamaedrys*) can be found brightening up hedge banks and grassy places in woodland rides and glades.

A bright but sunless day without a breath of wind is ideal to capture the full colour and subtlety of these exquisite flowers.

Fungi are very much part of the woodland scene, their fruiting bodies being visible evidence of the vast and complex process of decay which is occurring all the time. Here, flashlight captures the cloud of spores leaving the cap of a puffball (*Lycoperdon* sp.).

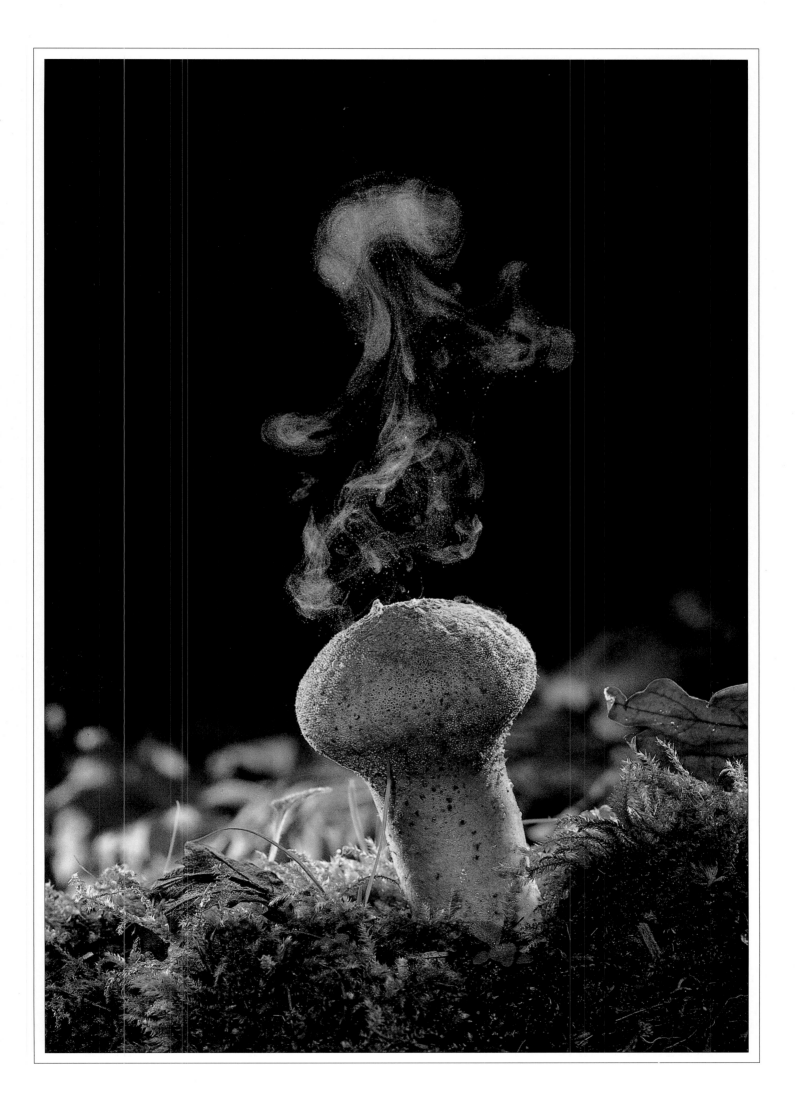

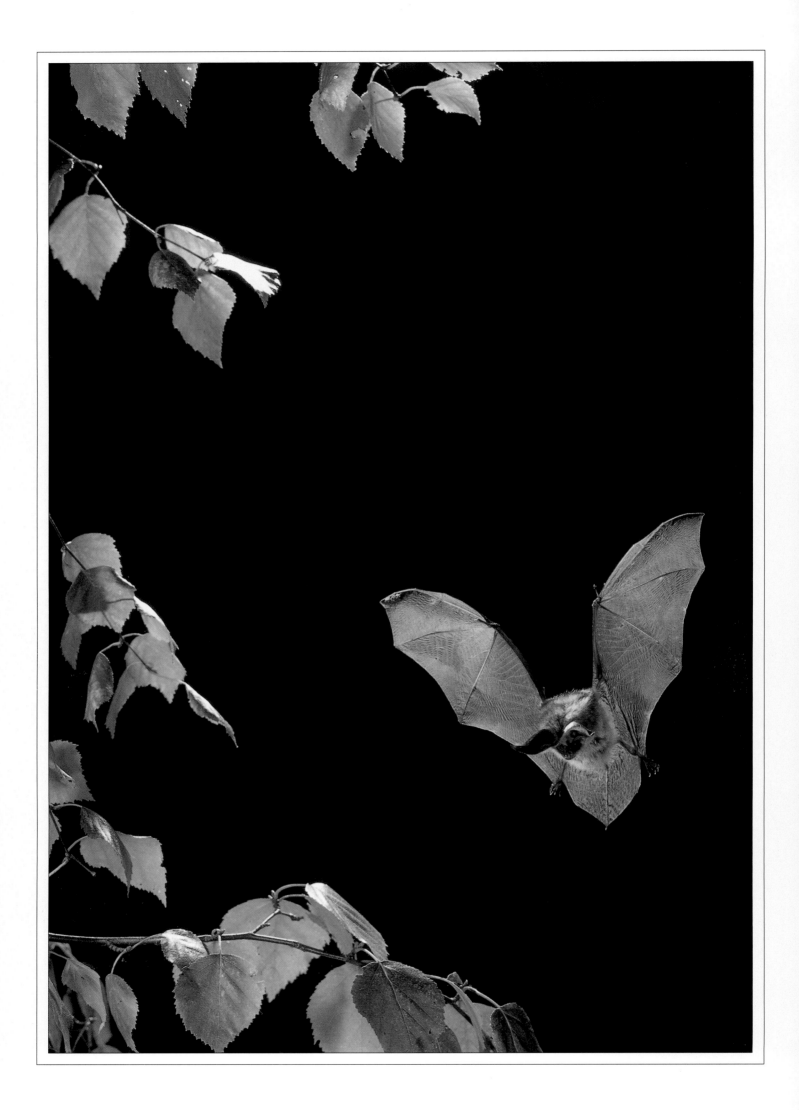

The **long-eared bat** (*Plecotus auritus*) is a medium-sized, slow-flying species, often preferring to hunt insects on foliage rather than chasing them through the air.

Sadly, all bats have decreased in numbers drastically over the last fifty years or so. Not only have poisonous sprays and prairie farming methods severely reduced the insect population, but we have been preventing bats from using their favourite roosts by discouraging them from entering lofts and by cutting down dead and hollow trees. Now, mercifully, and thanks to active conservationists and new bat-protection laws, these lovely creatures are beginning to acquire a better public image and even to inspire some affection.

The **badger** (*Meles meles*) is one of the oldest members of our fauna. Its frequent appearances in Saxon place names bear witness to this fact – there are 'Brocktons' and similar names throughout Britain. Yet the badger has always been harried and persecuted by man. In the past it was badger-baiting with dogs, and more recently it is gassing by government officials who claim that the animals spread tuberculosis in cattle.

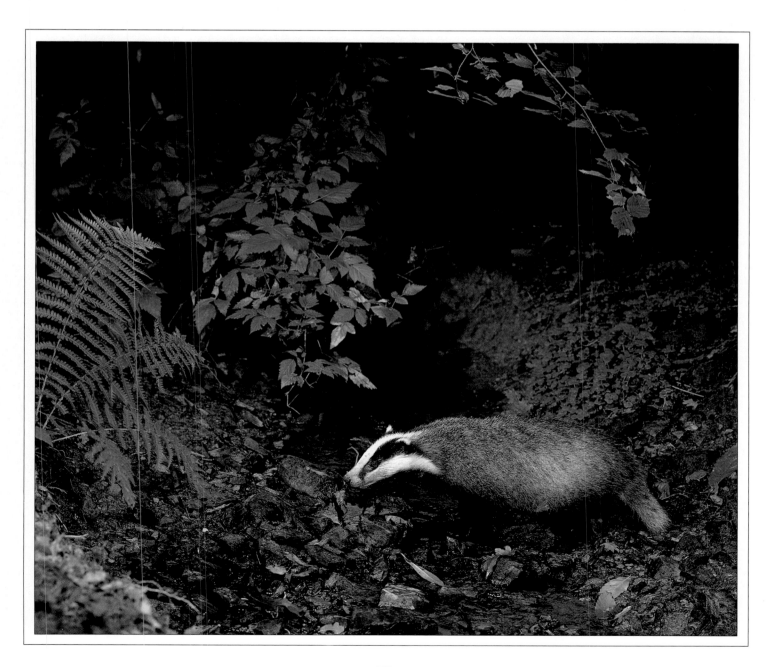

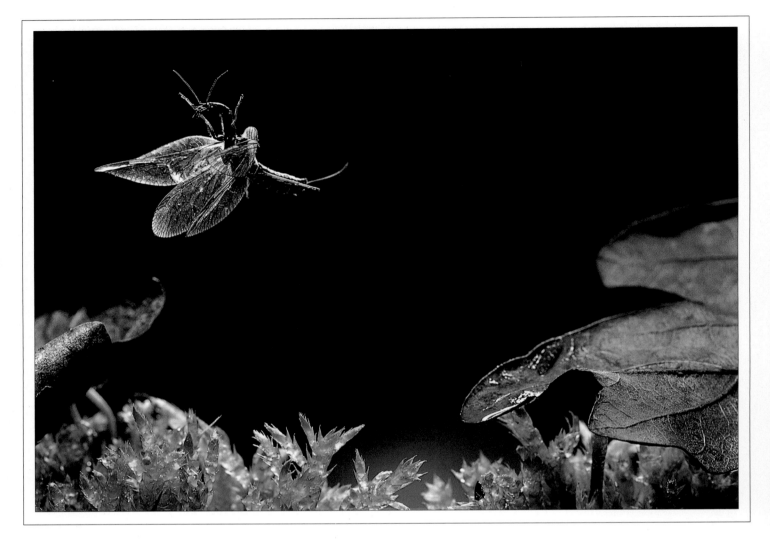

Snake-flies are peculiar-looking insects with long, neck-like extensions to the thorax and needle-like ovipositors in the female.

This species (*Raphidia notata*) may be found amongst the rank vegetation of oak and pine woods, the larvae feeding on the grubs of wood-boring beetles and other burrow-inhabiting insects.

In flight this large snake-fly makes a somewhat ominous buzzing sound, although the creature is utterly harmless. The adult is largely nocturnal – hence the dark background.

One rarely hears of snails being discussed in glowing terms so here I have tried to show their attractive qualities as a **banded snail** (*Cepaea nemoralis*) glides between two patches of stagshorn fungus.

As is so often the case, natural-looking lighting does much to convey a feeling of realism in a photograph. Here, the use of flashlight in a conventional manner would have killed the whole effect.

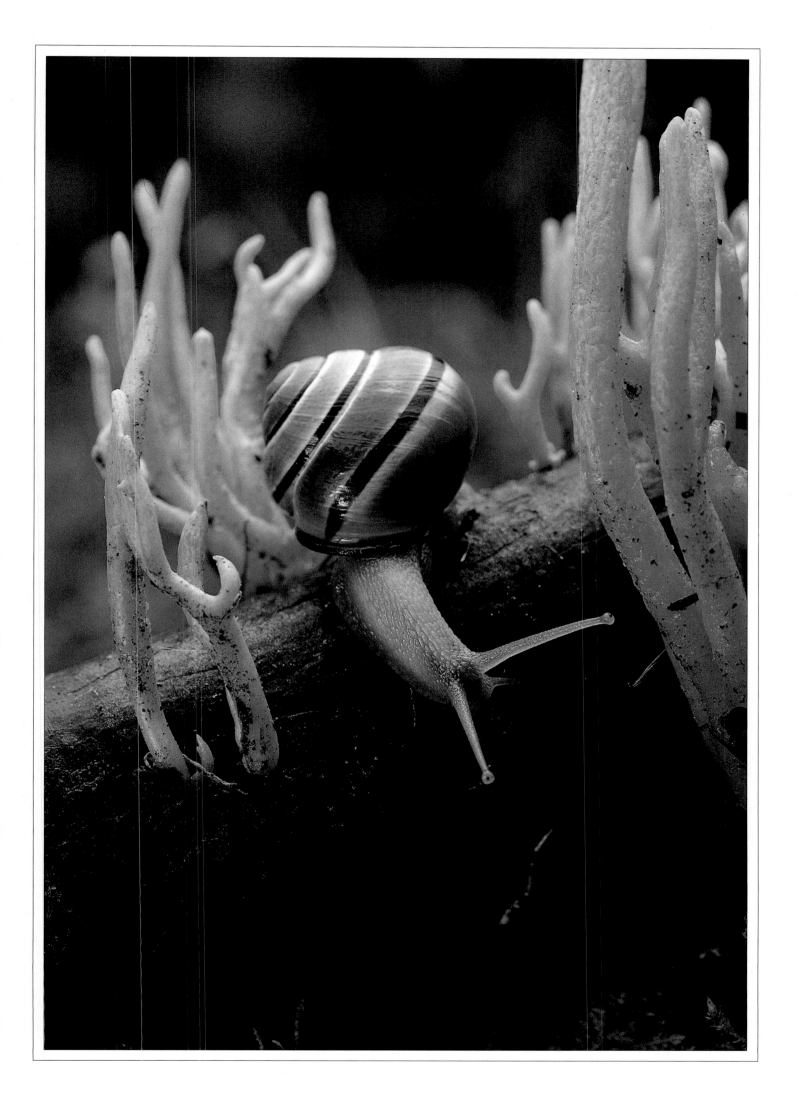

FRESH CHALLENGES

1984–86

The beauty and subtlety of natural light is difficult and sometimes impossible to match with flashlight, yet there are numerous occasions when electronic flash is preferable – for instance when working in the dark, or for stopping rapid movement. A less obvious example is when daylight gives too much contrast or is aesthetically dull.

Rather than adhering to an obvious theme, the photographs in this last section feature subjects taken in the mid-1980s. They represent the newest developments in my work, and were taken in widely varying conditions, but apart from three they were all exposed with electronic flash.

Clearly though, flashlight needs to be used with discretion in nature photography as it is crucial that the lighting appears as natural as possible. Crude, insensitive lighting can not only drain all feeling from a picture, but also impart a contrived and artificial look to a wild subject.

Visualizing the final image in terms of viewpoint and lighting is a prerequisite to sound flash photography. For example, some twenty years after leaving my childhood home I returned to photograph the kingfisher (page 105) once again. It was still nesting along its favourite stretch of stream within a hundred yards of the mill house.

To pre-compose the picture I hid amongst the foliage, watched the bird fly back and forth, and worked out a plan of action. To show off the shades of iridescent blue, I chose a slightly rearward view, which was partly achieved by persuading the bird to modify its flight path a little. It was also important to include the entrance to the nest and part of the clay bank, together with signs of the grassy turf above and a hint of water three feet below. To enhance all these features and suggest the dank, shadowy stream, each of the four flash heads needed to be carefully positioned. With this sort of planning, the picture not only conveyed the brilliance of the bird but also the charm of its habitat.

The sad, doleful expression on the face of this **red colobus monkey** (*Colobus pennanti*) seems to reflect the distressing plight of wildlife in Africa. In the past these lovely animals were ruthlessly hunted for their fur, almost causing the extinction of one colobus species. Now they are protected, thankfully, although they have to contend with habitat destruction instead.

Colobus monkeys can generally be recognized by their long fur, which hangs down their sides like a silky garment.

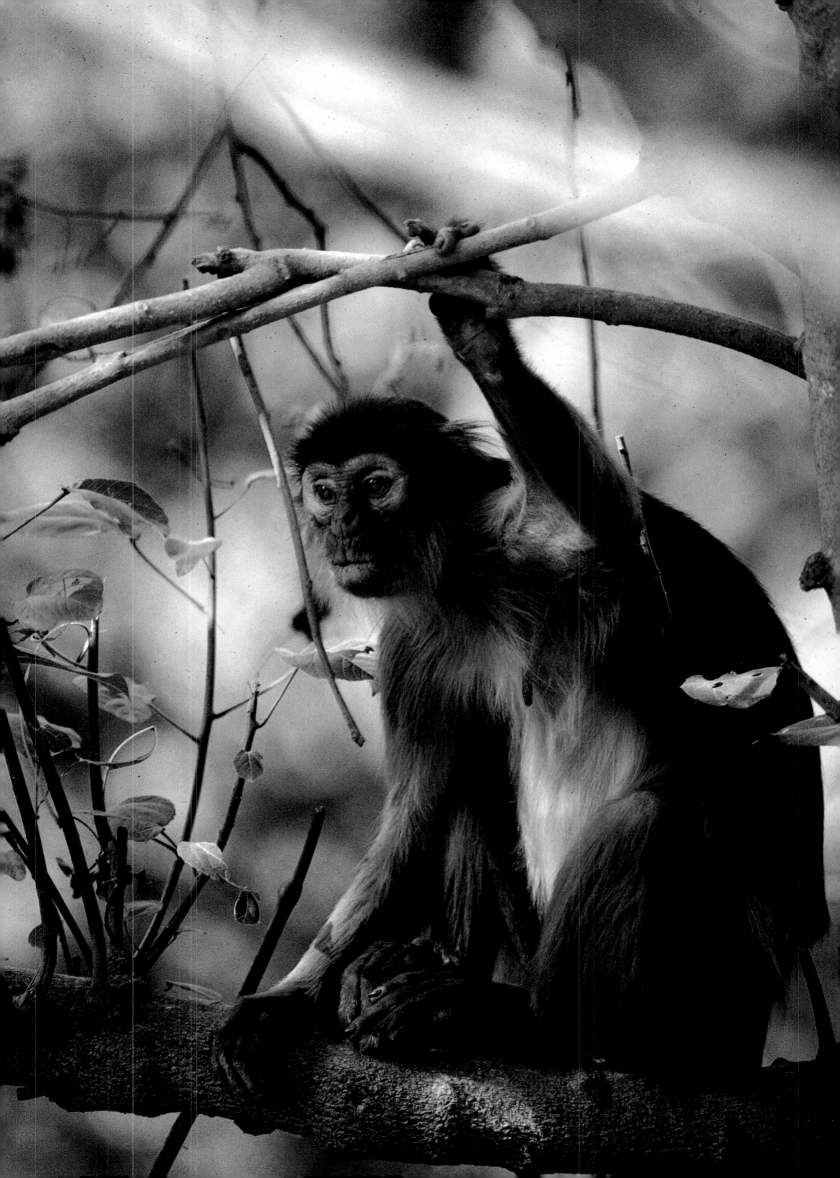

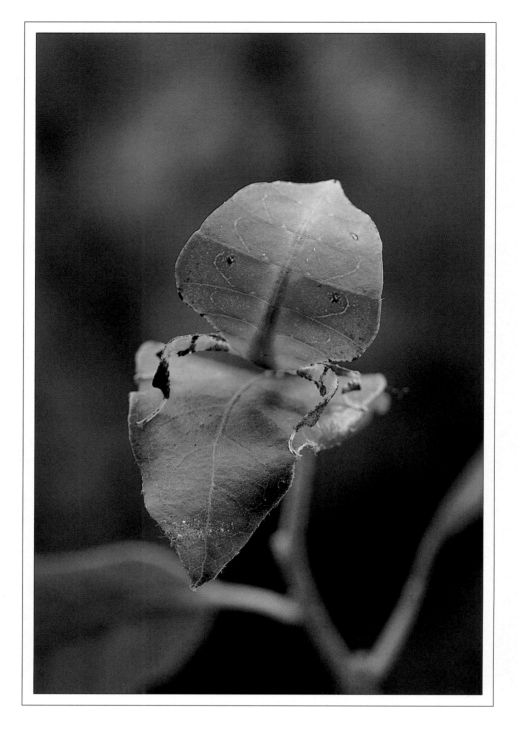

One stunning example of the way in which evolution moulds the form of living things is camouflage. It has taken millions of years of natural selection for this **leaf insect** (*Bioculatum cifolium*), *above*, to resemble a leaf. Yet the habitats which support such a wealth of species are still being relentlessly eradicated.

Praying mantids (*Mantis religiosa*) have been viewed with curiosity and superstition ever since man first encountered them. This is hardly surprising when one considers their sanctimonious appearance and their uncannily human ability to rotate their heads to follow movement.

Mantids lead a totally predatory existence, feeding voraciously on insects and sometimes lizards, birds and frogs. In fact there seems no limit to their appetites – even when stuffed with food they will continue to lash out at any prey that comes within reach of their lethally-armed forelimbs. The majority of species are beautifully camouflaged to match their surroundings, allowing them to stalk or lie in wait for their victims without detection.

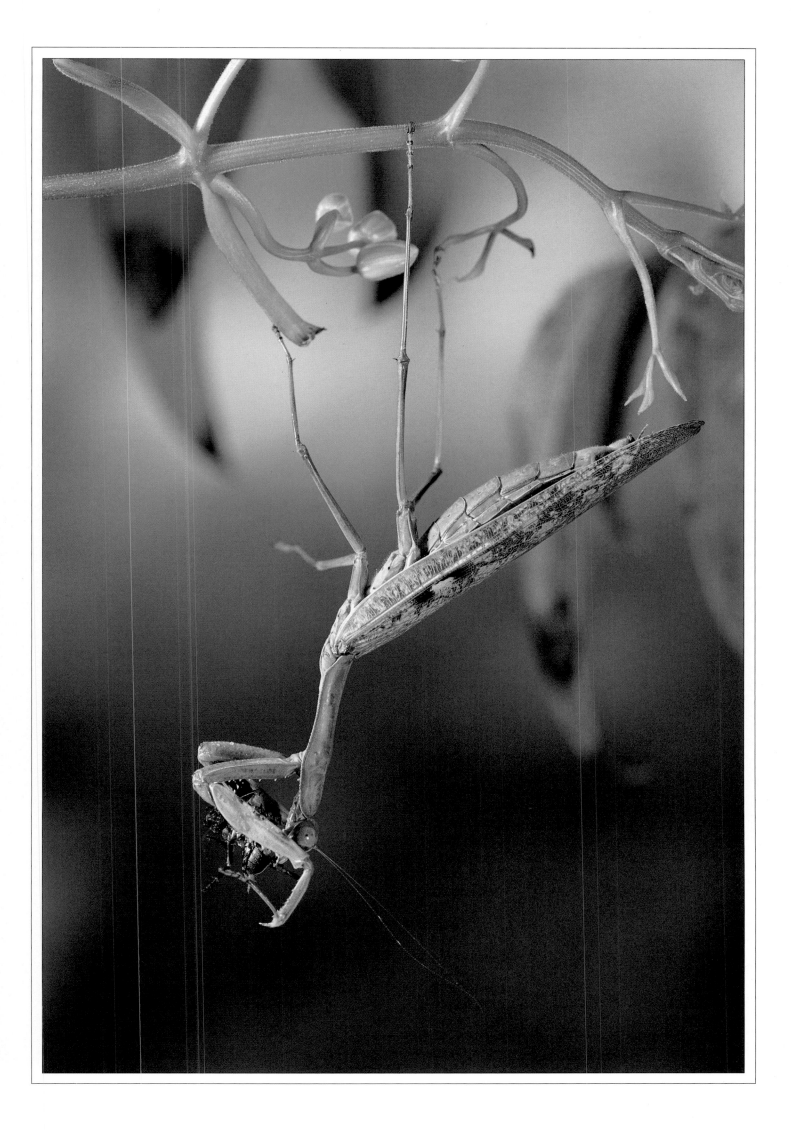

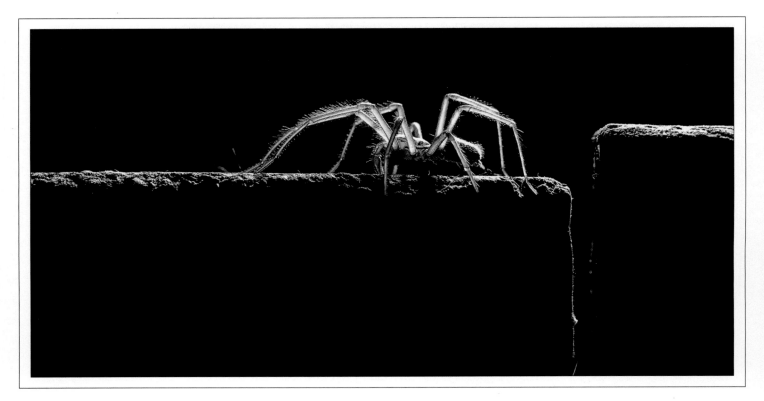

In contrast to the picture opposite, a more aggressive approach to lighting was employed for this **house spider** (*Tegenaria domestica*). A touch of backlighting not only shows up the hairy legs, but also helps to dramatize the somewhat sinister appearance of this familiar if unwelcome guest – a creature which many, including the writer, view with terror. Nevertheless, spiders are fascinating creatures.

One of the most enchanting of European dragonflies is the **common agrion** (*Agrion virgo*), *right*. It can most frequently be seen performing courtship dances in the dappled sunlight filtering through the leaves overhanging the woodland streams it loves to haunt. At other times when the weather is cooler, the insect may be found resting in the shade not far from the water's edge. This picture was intended to capture the soft quality of overhead light characteristic of a dull day.

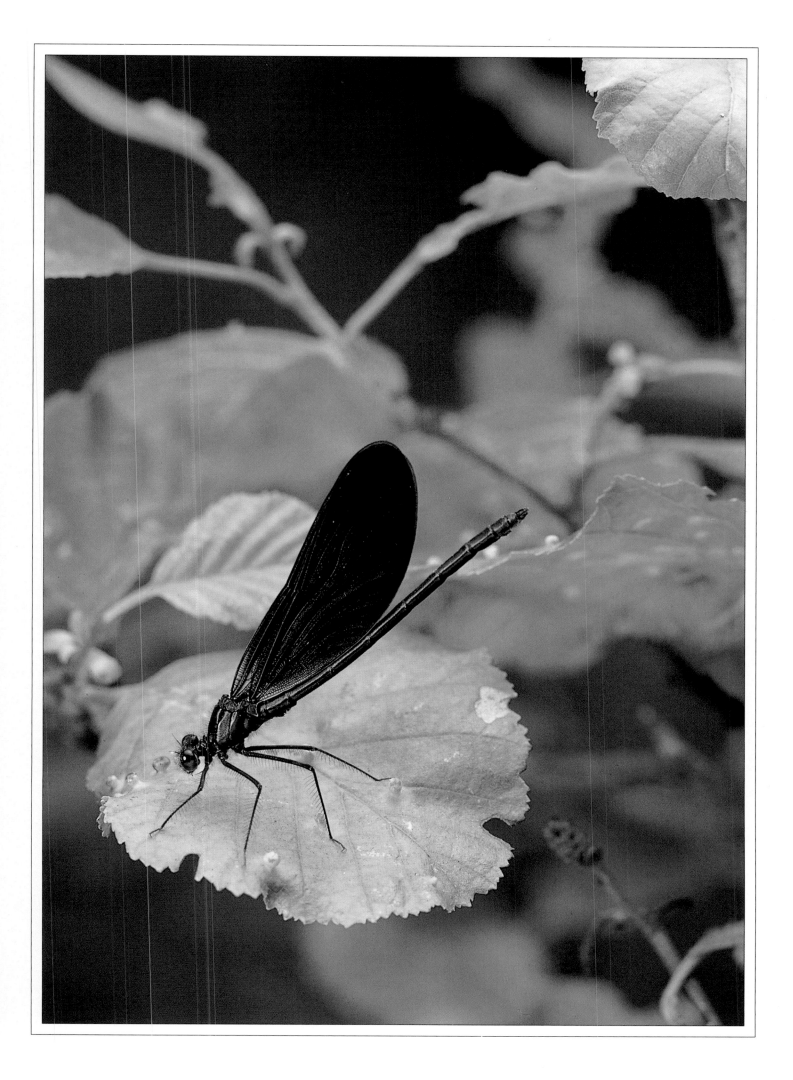

Closely related to the wood mouse, the **yellow-necked mouse** (*Apodemus flavicollis*) was not described as a separate species until the end of the last century. However, it is larger and the brownish spot often found on the chest of the wood mouse extends round to form a yellow collar. It is also more apt to bite!

Like all field mice, the yellow-necked mouse is largely nocturnal and frequently enters our houses in autumn to become a guest of those whose garden has been its home throughout spring and summer.

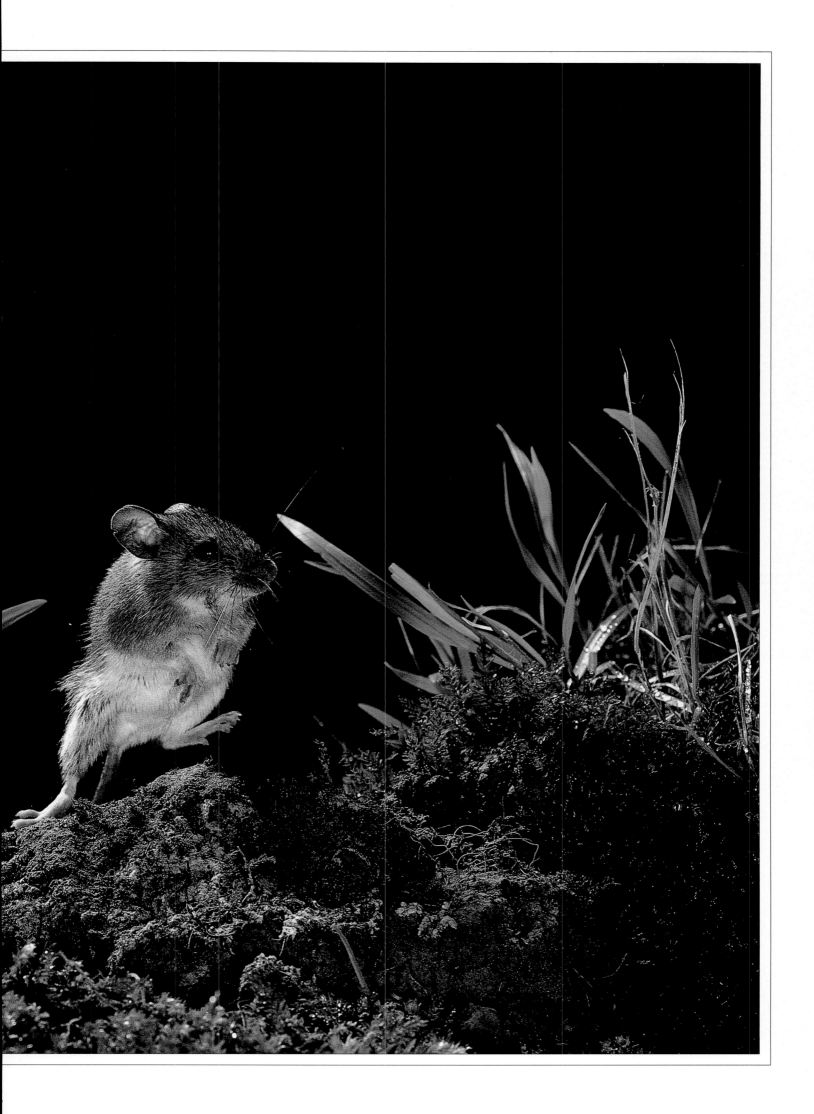

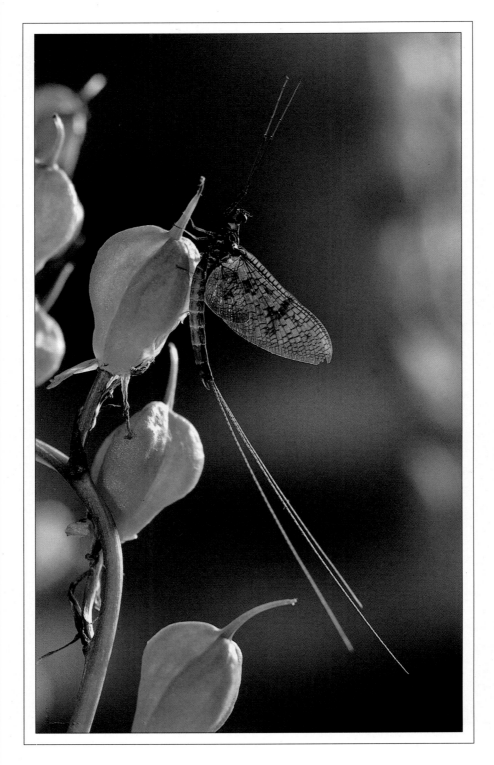

The sight of the first **mayflies** (*Ephemera* sp.) fluttering in the warm air is a sure sign that summer has finally arrived.

As adults mayflies have an ephemeral existence, living only a day or two, but the nymphs spend up to three years in the water. When ready to emerge they come to the surface, cast their final larval skins and fly weakly away. But, unlike any other insect, they still have to undergo another moult before they can reproduce. Soon after egg-laying the female dies, usually on the water's surface.

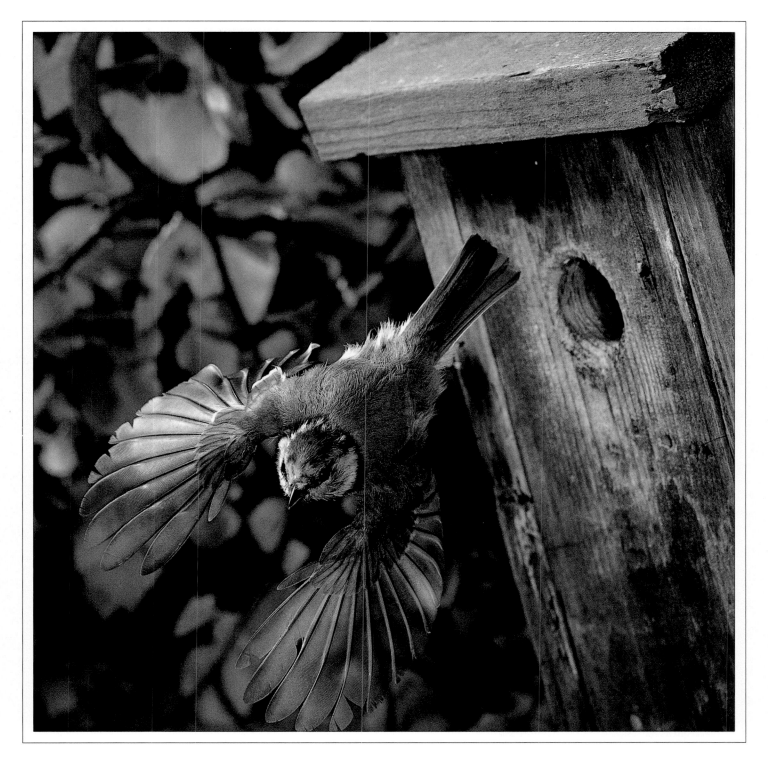

The **blue-tit** (*Parus caeruleus*) is one of the most familiar of garden birds, although it is really a woodland species. During the winter it constantly visits bird tables where the powder-blue colouring sets it apart from all other tits.

The nest is made in a natural hole or nest box, where up to fourteen young may be raised, a large brood requiring about a thousand caterpillars a day.

Do not be taken in by the sweet, smiling expression of this striking amphibian, because an adult **horned frog** (*Ceratophrys ornata*) is almost the size of a dinner plate and has a pugnacious reputation. It feeds on small mammals, birds, snakes and other frogs and is even reputed to be cannibalistic.

It lies half-buried waiting for prey to come by, and then suddenly jumps out from its hiding place to seize its victim. Like so many intriguing creatures, horned frogs come from South America.

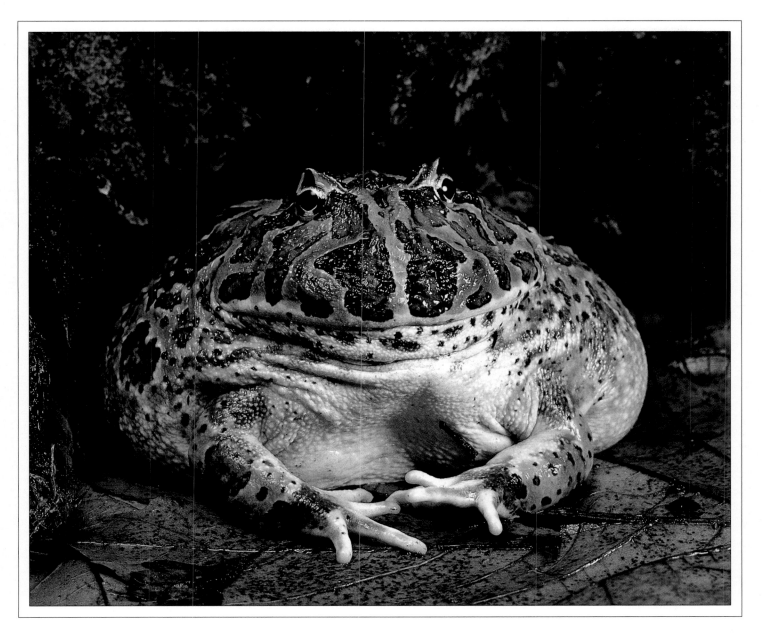

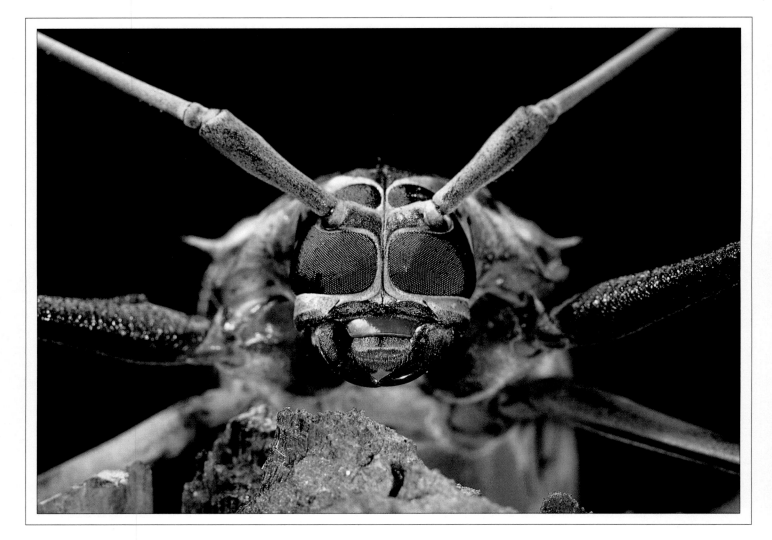

Although there may be nothing sensational about the photograph, this insect is far from ordinary. The **harlequin beetle** (*Acrocinus longimanus*) from South America is one of the largest and most awe-inspiring insects in the world, about 10 inches (25 centimetres) long, with menacing, spider-like legs, vicious mandibles capable of inflicting a painful bite, and extremely long antennae. The compound eyes, too, are unusually large for a beetle. The creature also has an unnerving capacity to generate a loud, rasping sound when upset. To add to this list of weird attributes, each beetle plays host to a colony of false scorpions, which live as scavengers under its wing cases.

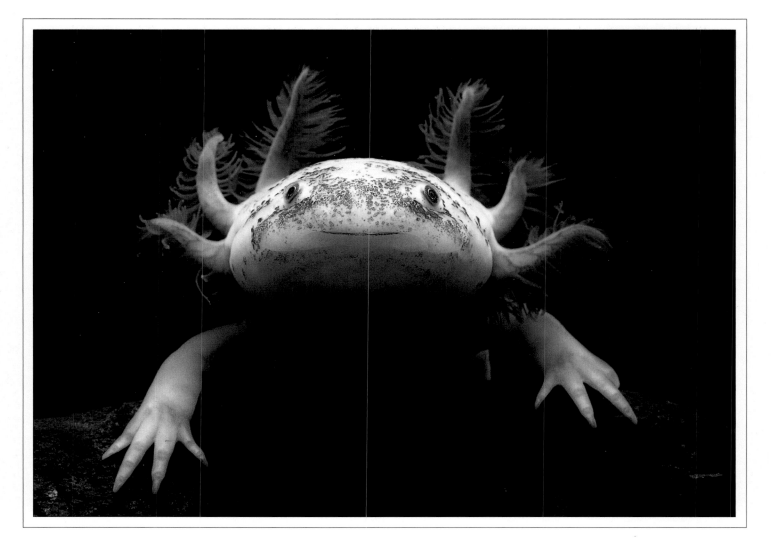

This bizarre-looking face belongs to an **axolotyl** (*Ambystoma mexicanum*), a large salamander from Mexico. The unusual feature about this amphibian is that it can reach sexual maturity without losing its gills, remaining to all intents and purposes a giant tadpole. Neoteny, as this phenomenon is called, can occur in a number of species of newts – usually where the water is cold or deep. It is also associated with albinism, as in this case.

Perfectly adapted to a life as a highly specialized parasite, the flea, in this picture a **cat flea** (*Ctenocephalides felis*), is truly an astounding insect. Its narrow, wax-like body, which is designed to slip and slither rapidly between the hair of mammals, is exceedingly tough, being difficult to destroy either by hand or by means of insecticides.

The leaping powers of fleas are prodigious. Powered by modified flight muscles (their ancestors were winged insects), the hind legs can rocket the creature to about 150 times its height. The acceleration forces are so high (around 300 g) that scientists were baffled as to how the insect avoids breaking its legs. It was later shown that rather than using the feet, the flea takes off from its much thicker knees. To show exactly how the launch is initiated was the object of this photograph.

Fleas only live as parasites during their adult stage, the larvae living on the ground, or carpet, where they feed on waste material. They locate their warm-blooded host by use of heat-sensitive organs, and then leap from the ground to its body. The leap also enables them to change hosts if the need arises.

The photograph was specially commissioned by the *National Geographic* magazine and took many weeks to accomplish. After finding a suitable source of fleas, the local vet, a satisfactory technique had then to be devised for handling the creatures in my home. To freeze the rapid movement during acceleration of such tiny objects, the flash units had to be modified to produce 1/60,000th of a second, three times their normal speed.

Naturally, timing was ultra-critical, requiring the optics of the trigger system to be refined and meticulously adjusted. In spite of all the elaborate electronic gadgetry, the operation needed to be conducted with the help of both hands, feet and mouth, and in total darkness!

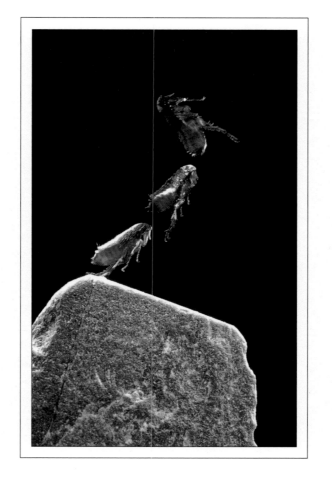

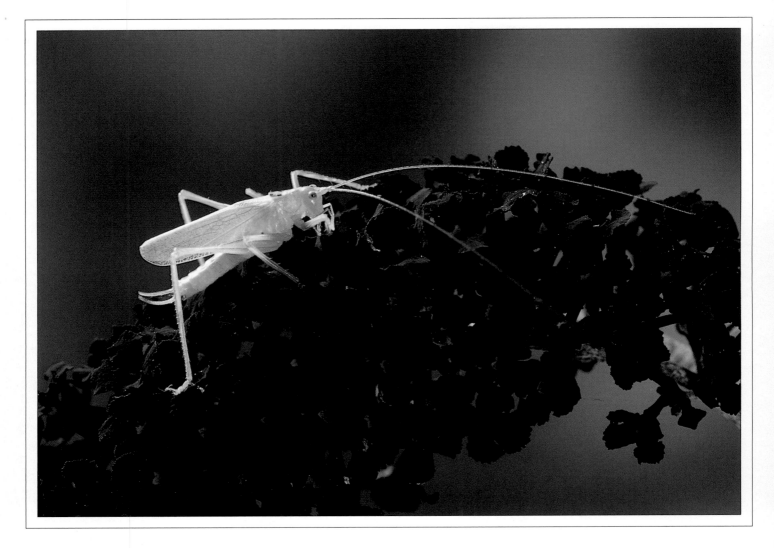

The bush crickets or long-horned grasshoppers differ from true grasshoppers in possessing long, filamentous antennae instead of short ones. Their 'song' is also produced in a different way, by rubbing a toothed rib of the left forewing against the margin of the right forewing, where the sound is amplified by a membrane.

The **oak bush cricket** (*Meconema thalassinum*), *above*, lives in oak trees in parts of Europe and the southern half of Britain. During the day the adults remain hidden in the foliage but become active after dark when they often fly indoors, attracted by lights. This one seemed very contented, feeding on the nectar of the buddleia.

Carder bees (*Bombus agrorum*), *right*, are really bumblebees, but instead of living in holes underground, they make their nests above ground. These, not unlike those of small birds, are made largely of grass and moss. Bumblebees differ from honeybees in that their colony is annual, and no honey is laid up for the winter months. The young fertilized queens survive the winter in hibernation.

This photograph was taken in an oakwood ride, with the help of flashlights to preserve a light, sunny feeling.

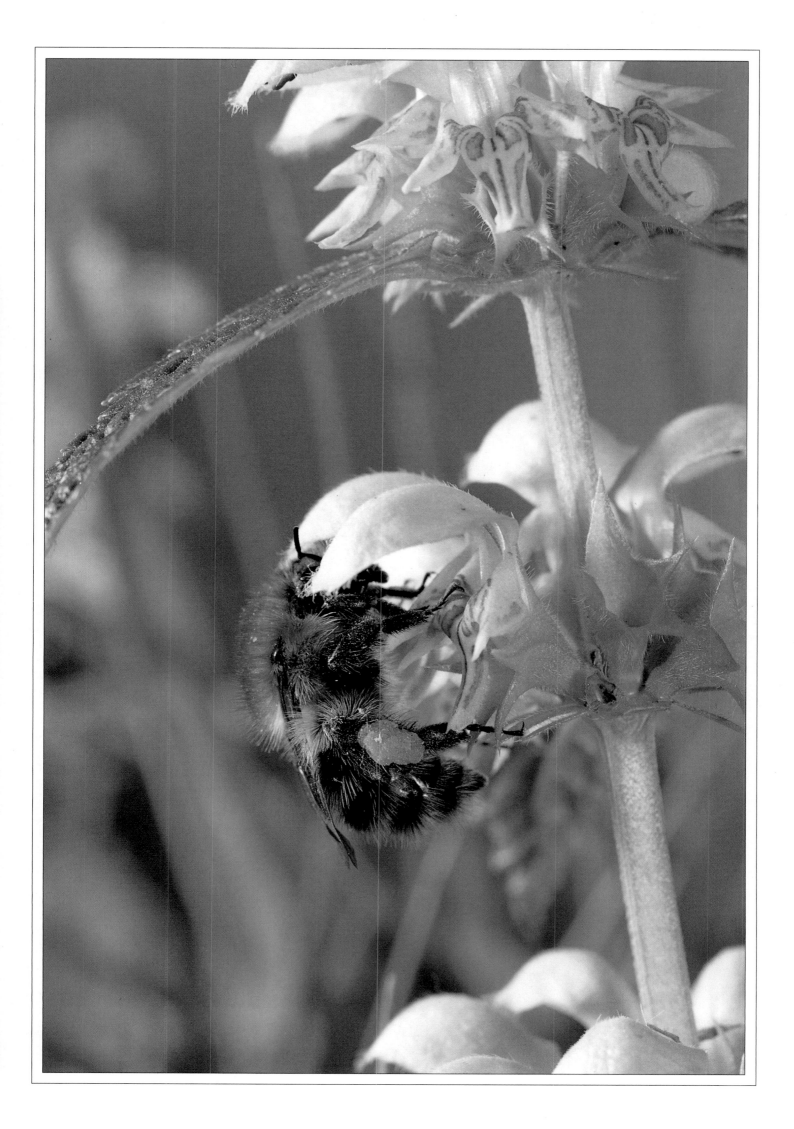

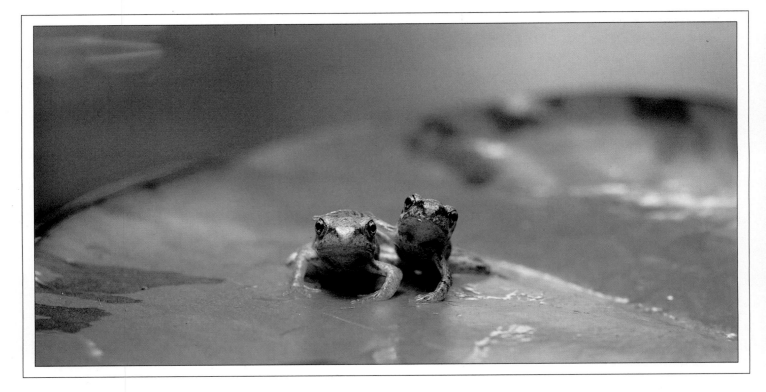

After spending nearly four months under the water as tadpoles, these two little **froglets** (*Rana temporaria*) are braving the outside world for the first time on a lily pad.

The mortality rate for tadpoles is extremely high as they are preyed upon by a host of creatures, including water bugs and beetles and dragonfly larvae as well as newts, fishes and birds. As they disperse over the surrounding countryside, their life out of water will be hardly less hazardous, as a whole range of new enemies will take a toll.

In rhyme and folklore, the spider and the fly are universal symbols for predator and prey. This little **jumping spider** (*Plexippus paykulli*), found throughout much of Africa and the Mediterranean, shared a hotel room with me while I was on holiday in Crete, and was duly encouraged to perform in front of the camera.

Rather than relying on web vibrations from struggling insects, jumping spiders depend on their large, sensitive 'headlight' eyes for locating prey, and leap onto their victims.

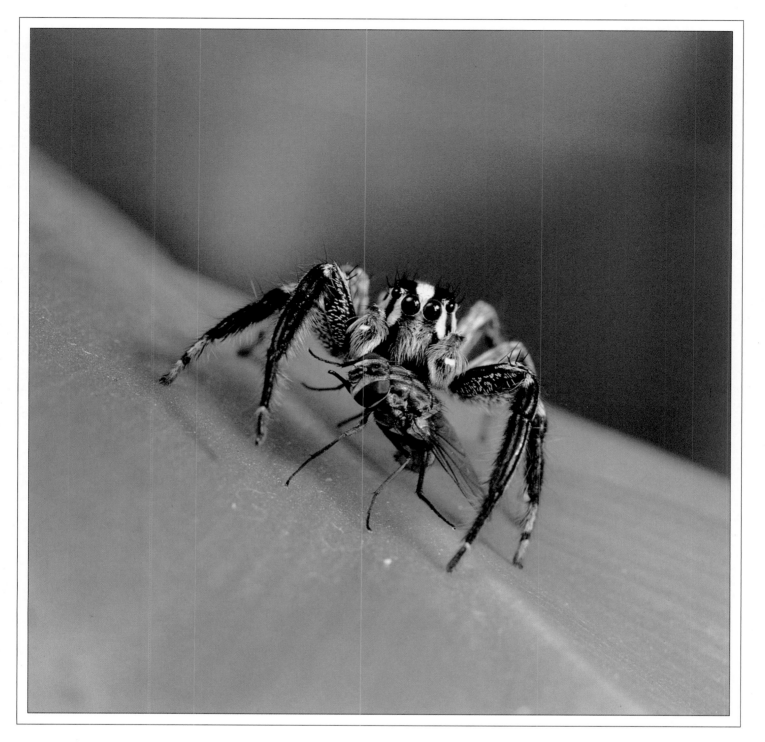

Here a **zebra spider** (*Salticus scenicus*), common on walls, stones and fences, is leaping from one pebble to another. I have always had an affection for jumping spiders, as these tiny creatures with their nimble bodies seem to be perpetually on the move in search of small insects. The jump is exceedingly rapid and is effected by hydraulic action within the legs. Before jumping, the spider deposits a blob of web at the point of take-off, and, as it launches itself into the air, a band of silk is extruded behind it.

Although I also employed multiflash to show this action, the technique is limited to black backgrounds and tends to impose certain photographic constraints by excluding the use of natural settings. Thus I often prefer to show a sequence of movement as separate pictures.

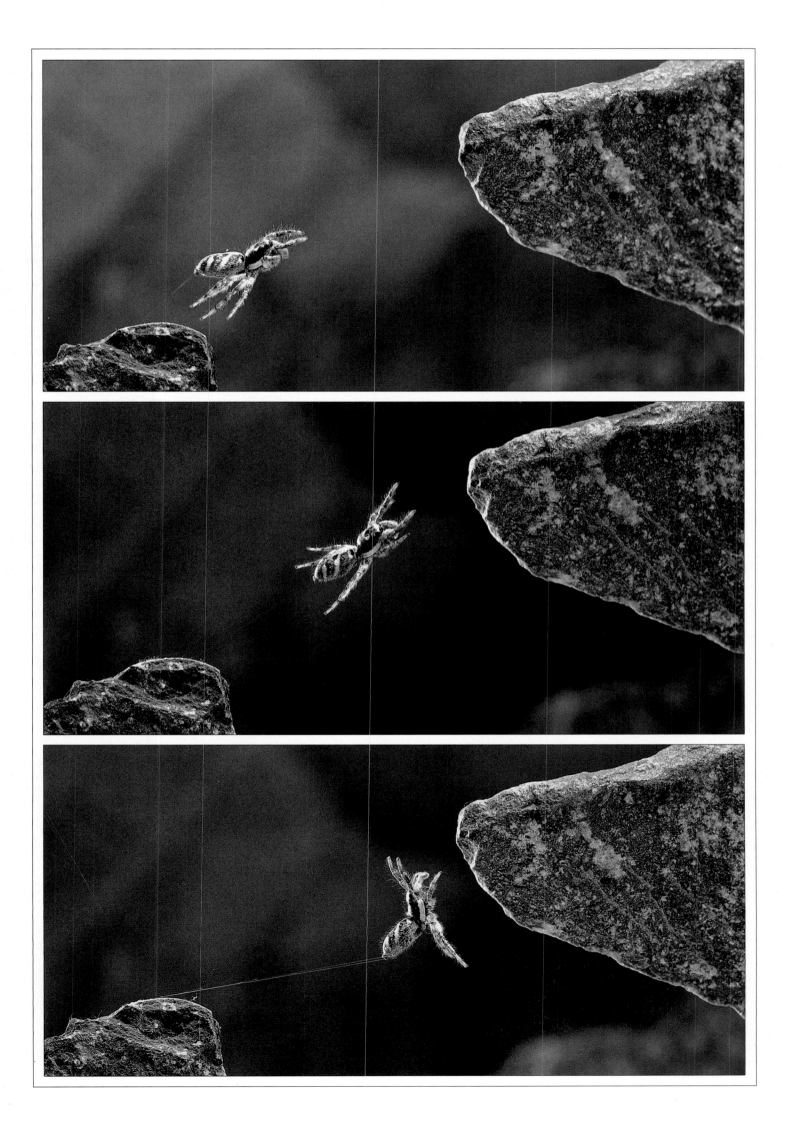

The **slow-worm** (*Anguis fragilis*), *below*, blind-worm or deaf-adder (it is not slow, blind or deaf – neither is it a worm or an adder!) is a legless lizard, with highly polished scales covering the vestigial limbs which have been discarded during its long evolutionary history.

Unlike snakes, slow-worms cannot stretch their mouths to accommodate large prey, so have to confine their intake to small insects, spiders, slugs and worms. This one was found under a stone on the South Downs and photographed *in situ*.

The **isopod** (order *Isopoda*), *right*, is really a desert woodlouse. During the daytime it lives underground, away from the desiccating heat of the sun, and comes out at night to feed on the few desert plants scattered about.

The picture was taken while on a short trip to the Negev Desert in Israel, to photograph desert snails.

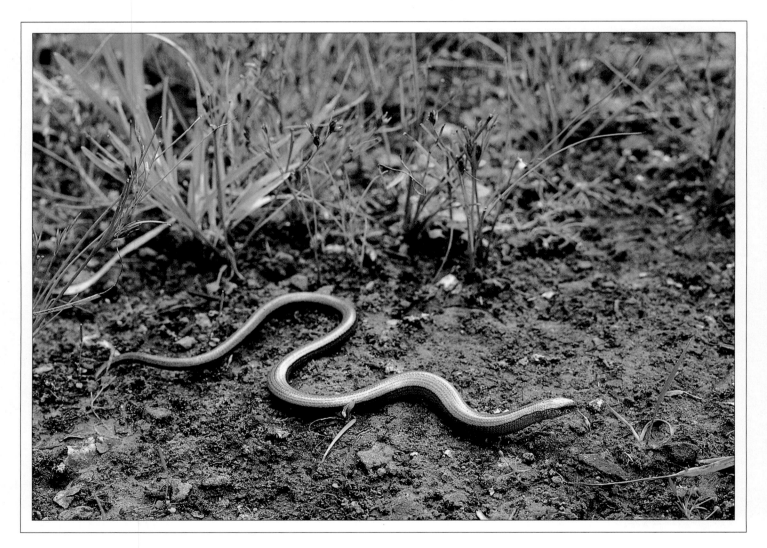

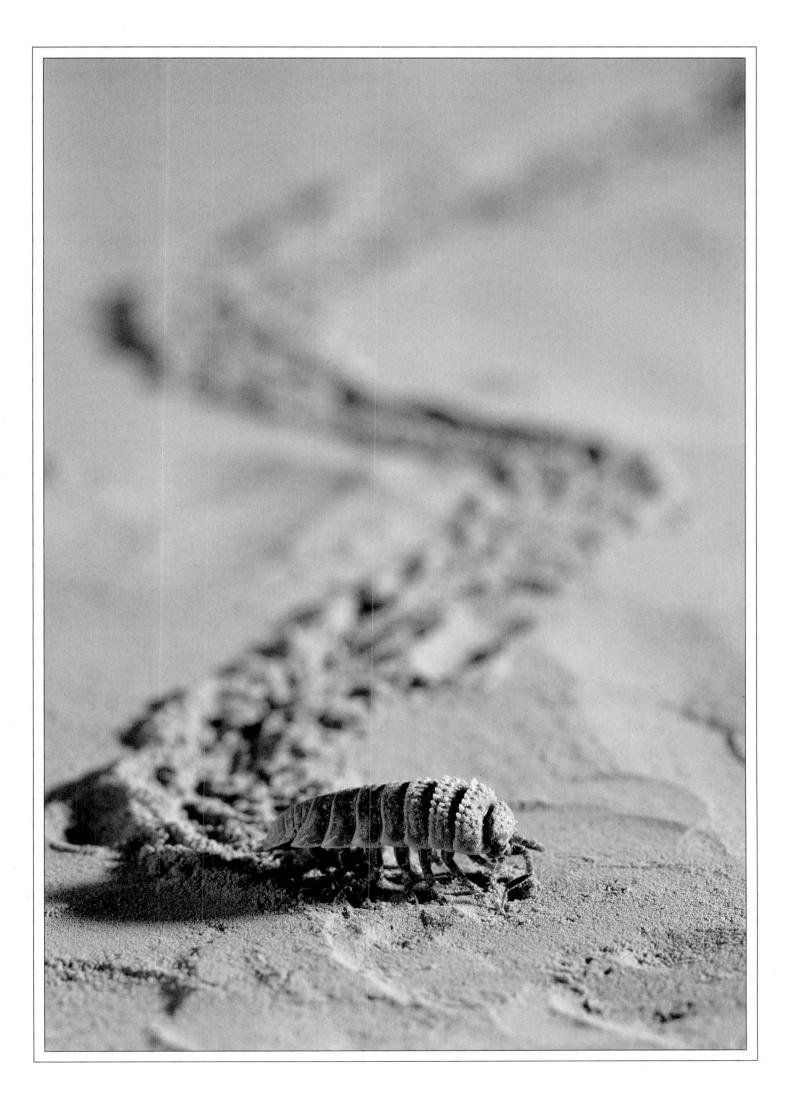

The shrill cry and, if you are lucky, a flash of iridescent blue may be the only signs of the exotic-looking **kingfisher** (*Alcedo atthis*) as it speeds past, low over the water. Here seen approaching its nest hole in the bank of a Surrey stream, the bird is carrying a stickleback to feed its hungry young.

Sadly, kingfishers are becoming increasingly difficult to spot, water pollution seriously affecting their populations. They have already been exterminated from most industrial areas.

Contrast this photograph with that on page 36. Here, much more habitat is included in the picture and a different lighting technique was employed resulting in a totally different effect.

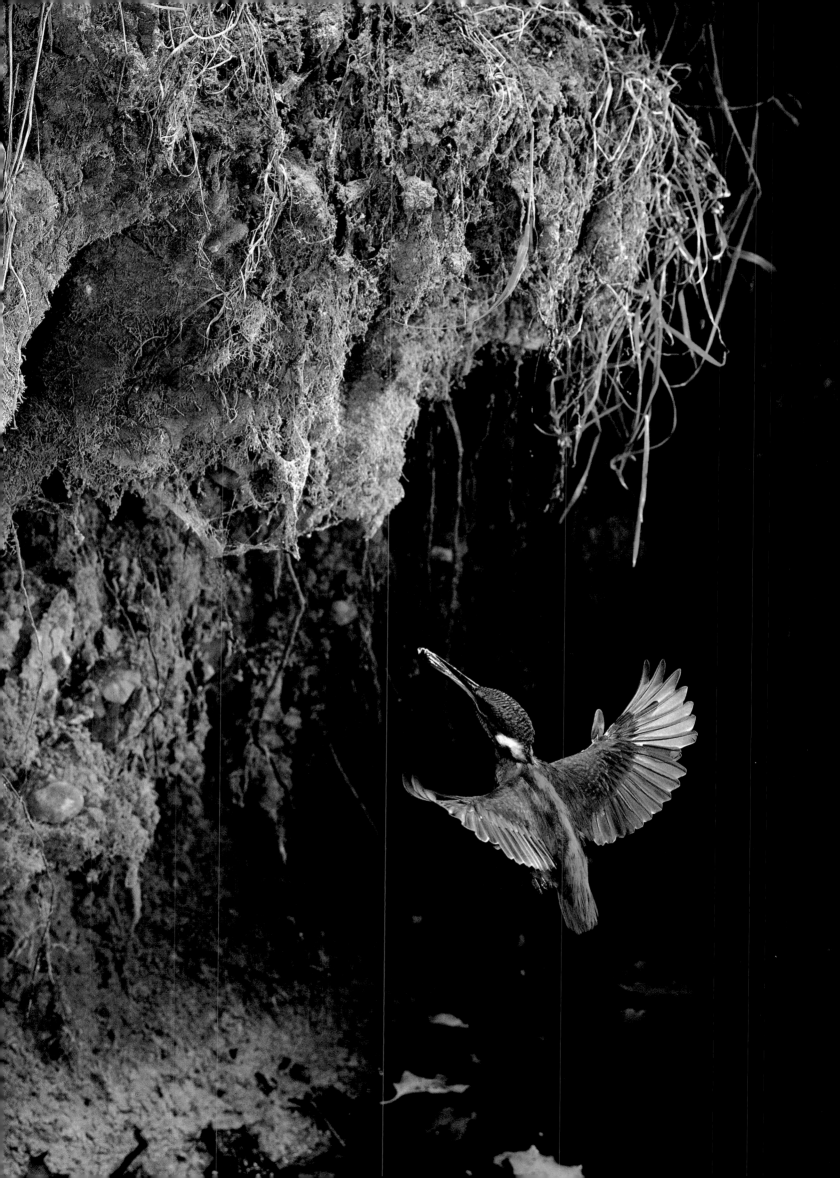

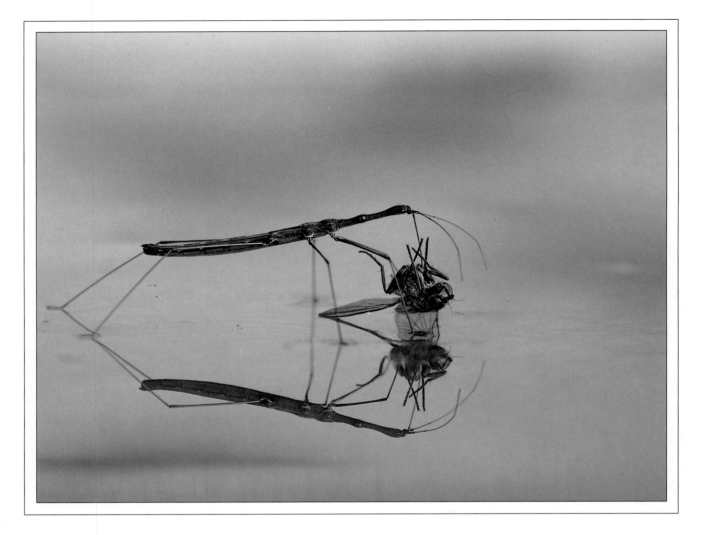

The **water-measurer** (*Hydrometra stagnorum*) is a true 'bug' which spends its life walking around with a measured tread on the surface of slow-moving or stagnant water. It makes a living out of half-drowned, struggling insects and other small creatures such as water fleas or mosquito larvae, which come to the surface to breathe. The water-measurer detects its prey by sensing vibrations on the surface film, then spears the victim with its piercing mouthparts.

To obtain both critical definition and soft, 'natural' lighting, carefully adjusted flash heads and reflectors were set up around a studio pond.

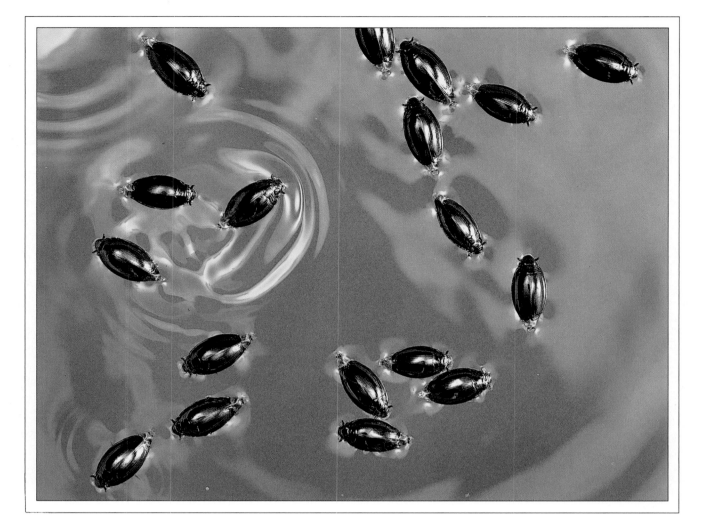

These ebullient little shiny-black **whirligig beetles** (*Gyrinus natator*) spend much of their lives gyrating in groups at great speed on the surface of slow-moving water, diving down when alarmed. Their eyes are unusual in that they are divided into two entirely separate parts, enabling them to see both above and below water.

The only way to stop the exceedingly rapid movement of these creatures and show up the surface ripples was to use high-speed flash.

Nature's ingenuity seems to be limitless, the **chameleon** (*Chamaeleo chamaeleon*) having more than its fair share of special attributes. In addition to its well-known ability to change colour within seconds, the chameleon can also look in more than one place at a time, each eye being able to swivel about 180 degrees in any direction quite independently. The animal waits, camouflaged and motionless, until an insect comes within range of the long tongue. At the moment of attack, both eyes are directed forwards to provide the stereoscopic vision necessary for an accurate strike.

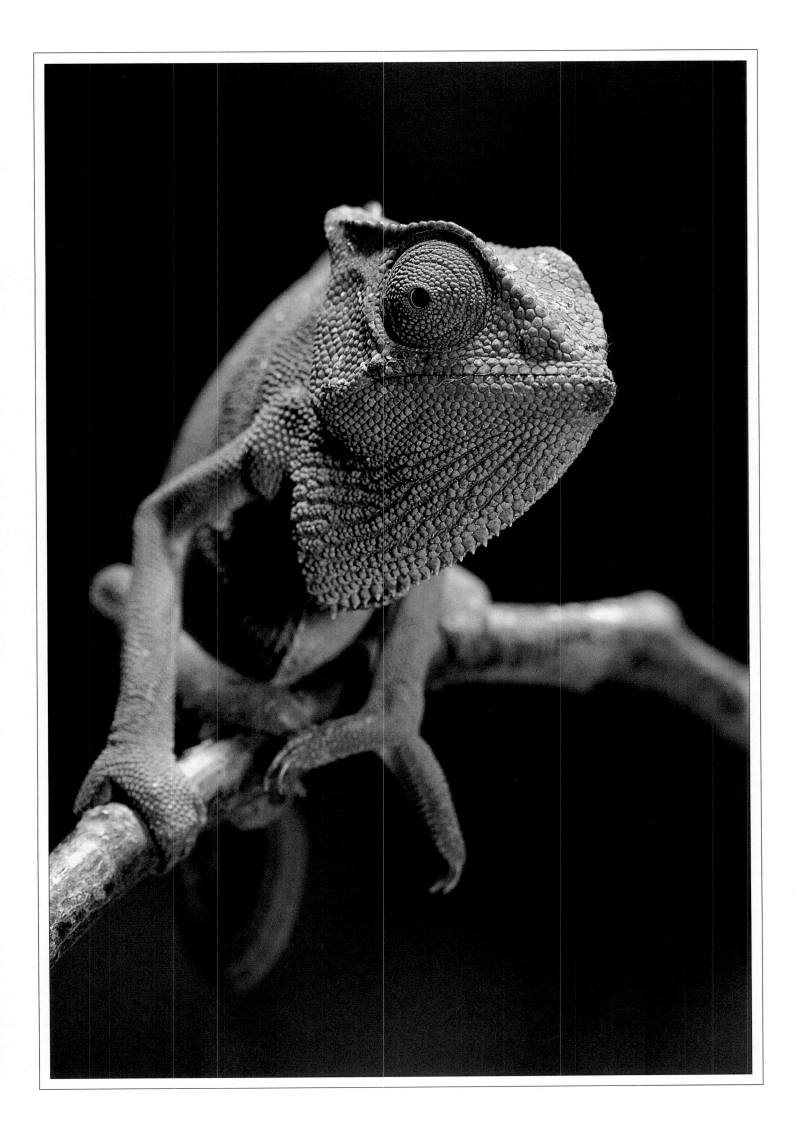

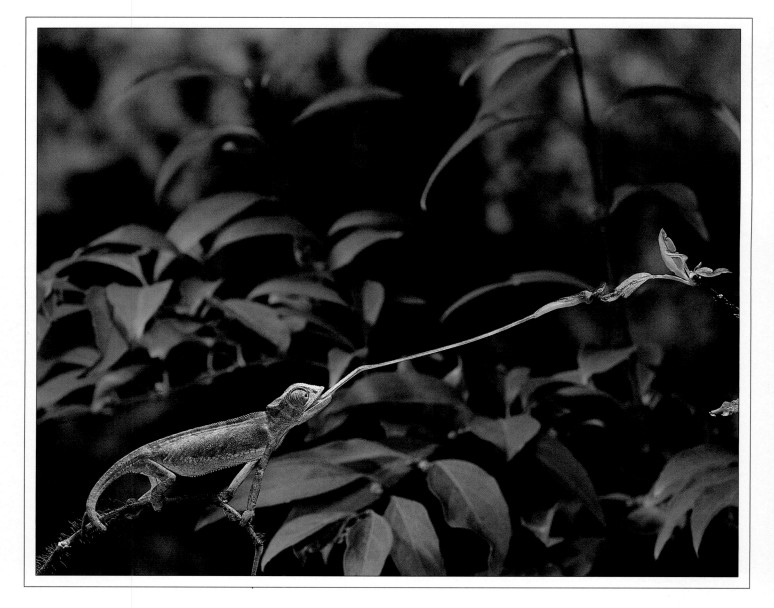

The **chameleon**'s most fascinating characteristic is the extraordinary action of its tongue, which can be rapidly extended to about twice the length of its body. As contact is made the victim is held fast by the sticky tip, although photographs show that the tip can actually grasp the insects.

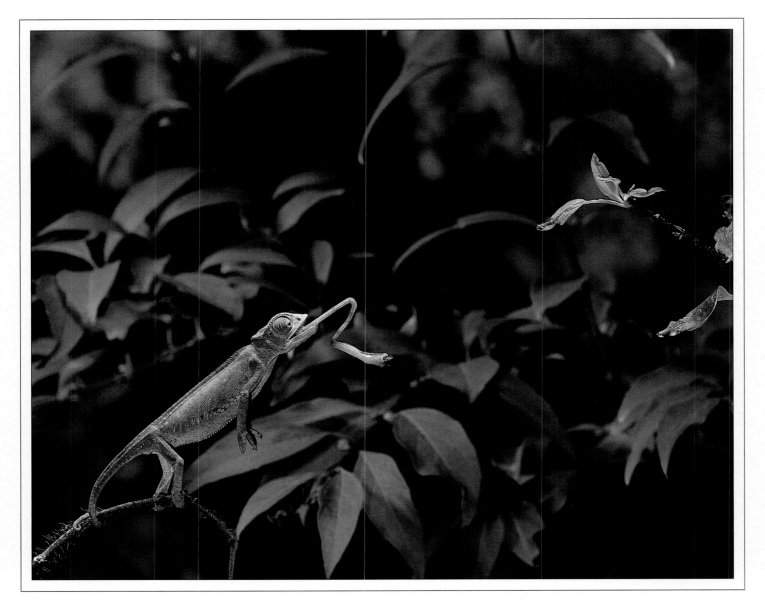

When not in use the tongue is folded around a long thin bone in the floor of the mouth. This is levered forward during the strike, *right*, and accounts for the tongue's kink seen in this photograph.

Tree frogs, *following page*, are specially adapted for a life in the trees. With feet equipped with sucker discs, they are able to grip onto almost any surface – even glass. The majority of tree frogs are powerful jumpers and can launch themselves at an insect accurately enough to engulf it as they land.

Here, with the aid of multiflash, two stages of the take-off of a **European tree frog** (*Hyla arboria*) are shown.

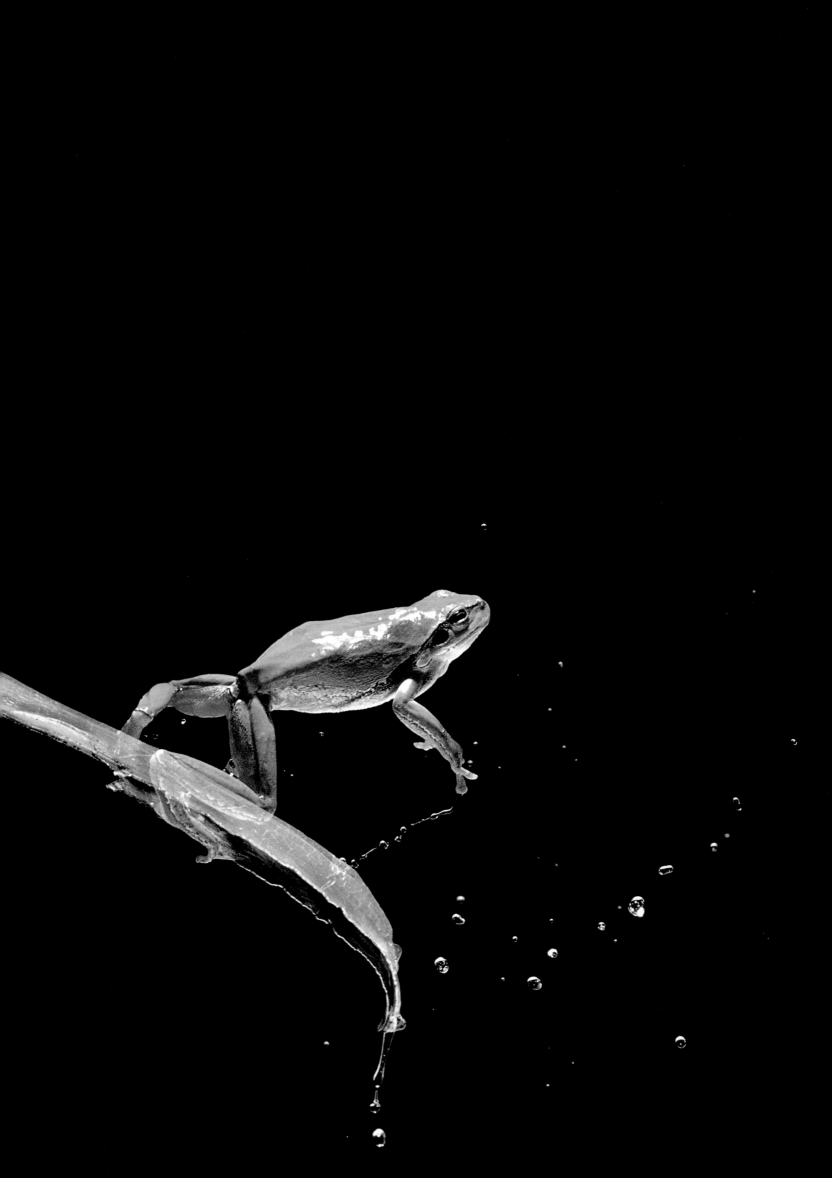

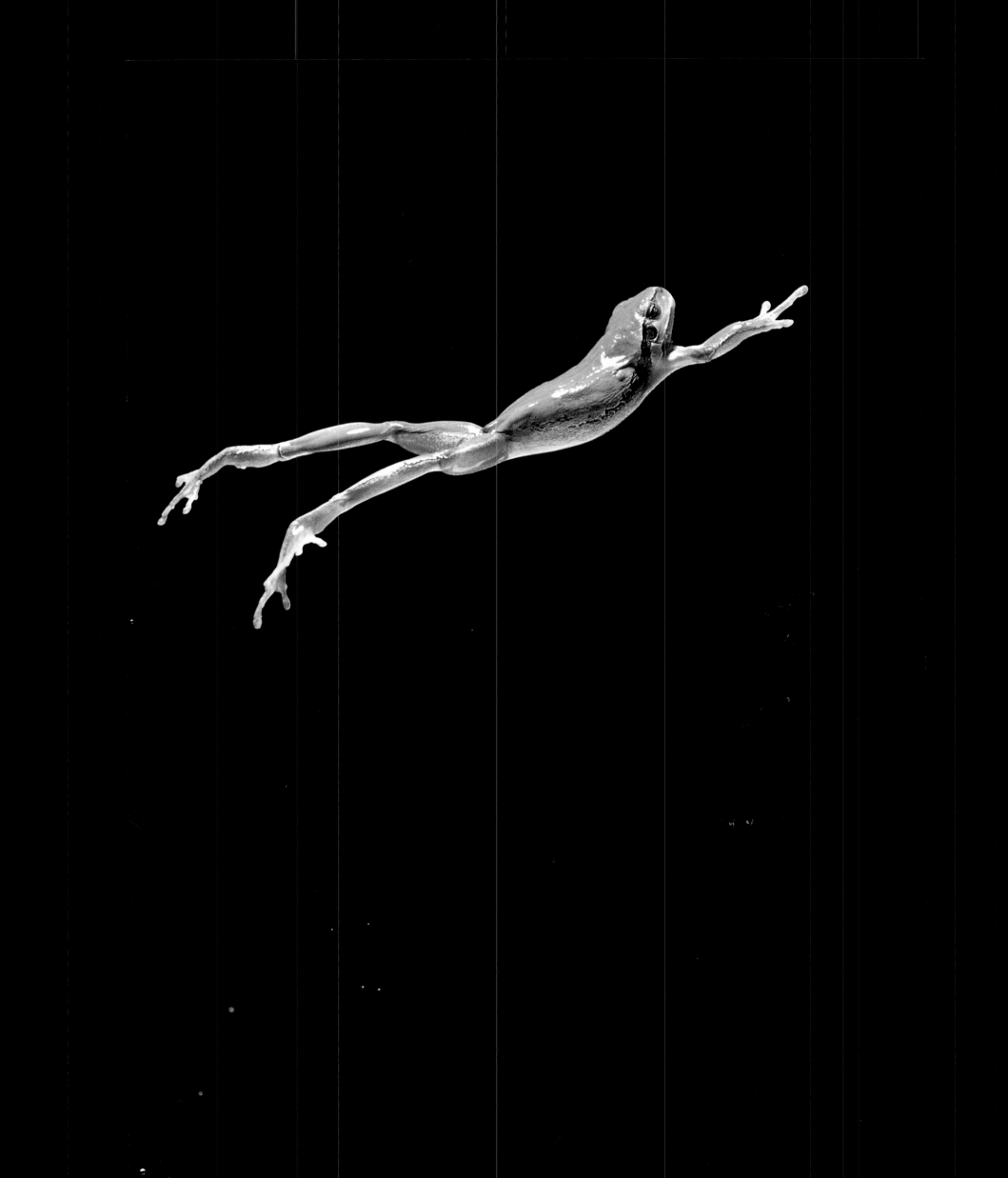

The **clouded yellow** (*Colias croceus*) is one of those butterflies which appears in profusion one year, but then vanishes from sight for several seasons. In fact it is a migrant to the British Isles from southern Europe, sometimes arriving in huge numbers during late summer. This one was found feeding on thistles in the meadow of a local nature reserve where it was caught and taken inside to be photographed. Two hours later it was released in the same spot.

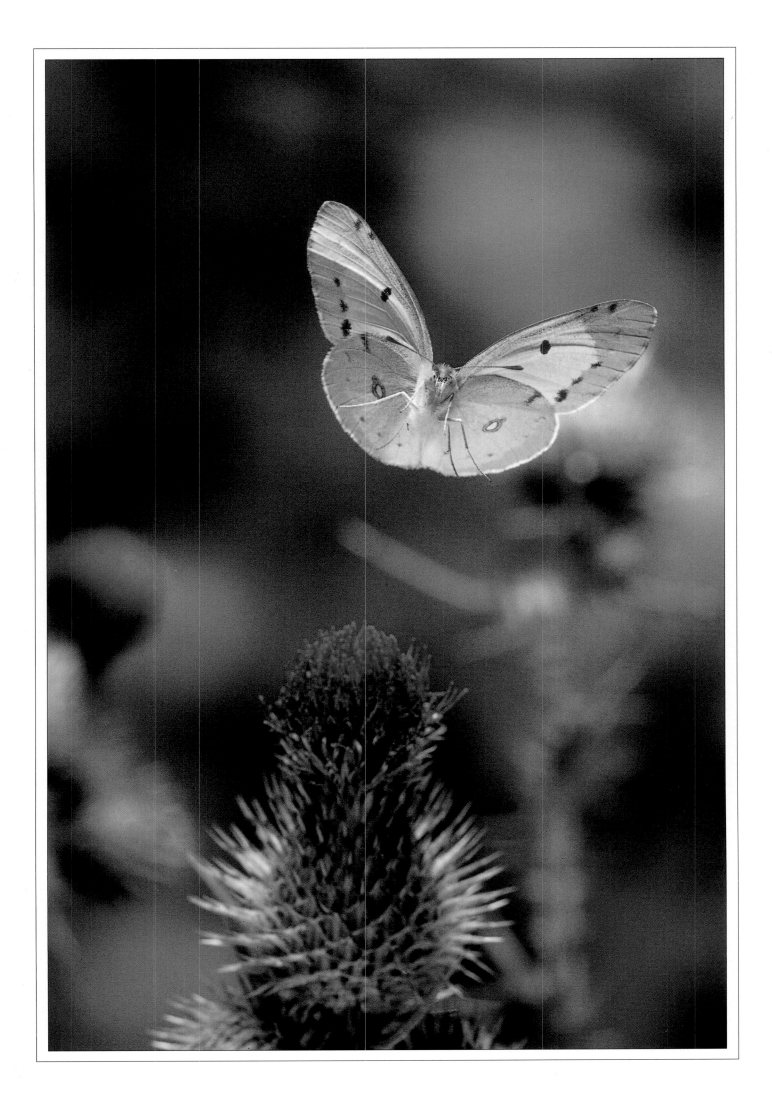

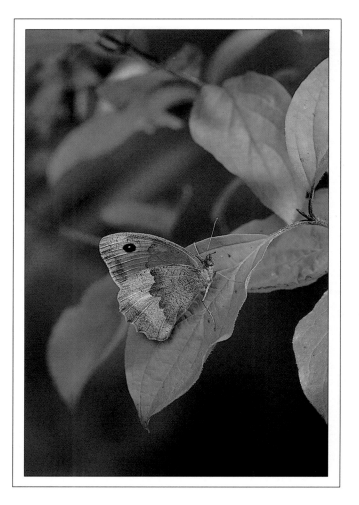

Found in rough grassland and woodland clearings, the **meadow brown** (*Epinephele jurtina*) is one of the most common and widespread butterflies, and can often be seen flying on overcast days, but this one is spending a dull and cold afternoon resting on a dogwood leaf.

The **meadow vole** or short-tailed field vole (*Microtus agrestis*) is a little mammal of endearing appearance and habits. It lives in meadows and pastures, venturing into gardens and woods where it searches for bulbs, roots, seeds, snails and insects. Occasionally meadow voles may assume plague proportions when they become a serious nuisance, but this is usually caused by the slaughtering of the voles' natural predators, such as owls, hawks, foxes and weasels.

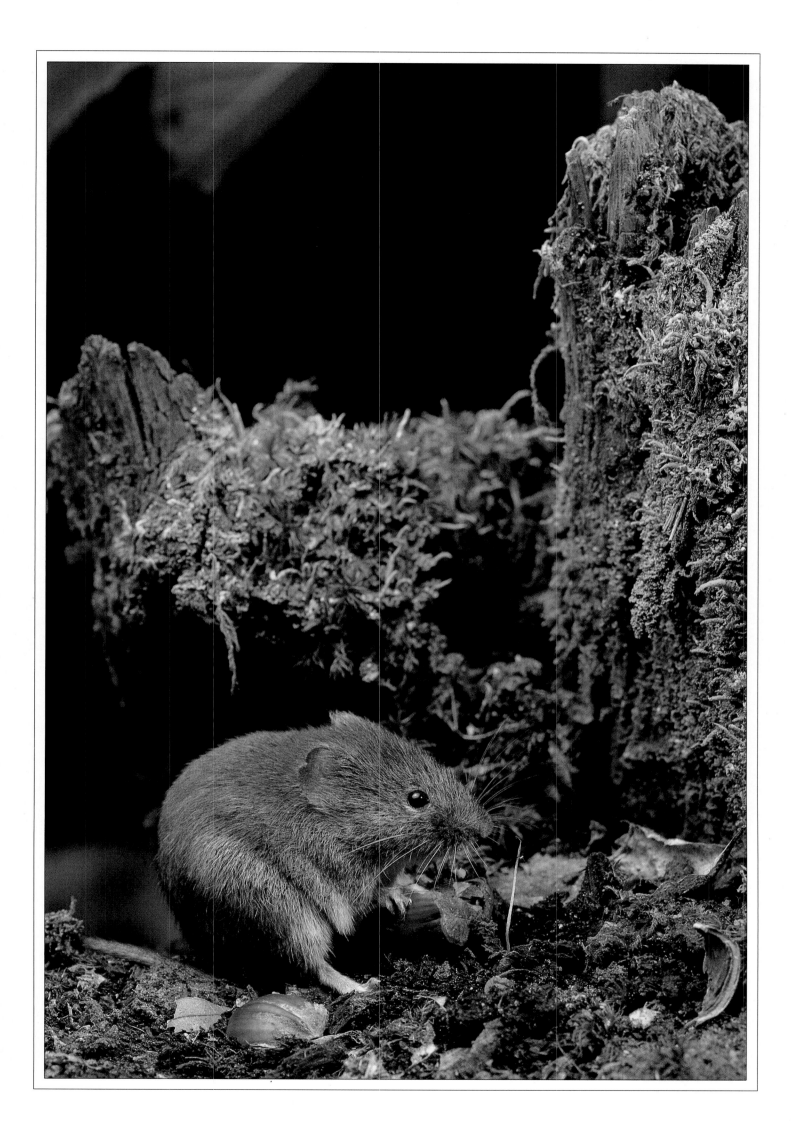

The **marbled white** (*Melanargia galathea*) is not a 'white' at all, but a member of the 'brown' family. It can be seen in July and August, flying among the tall grasses of rambling meadows, rough hillsides and downs, in many parts of Europe and Southern England. Most browns are not strong fliers, and overwinter as larvae, feeding on the grasses during mild winter spells.

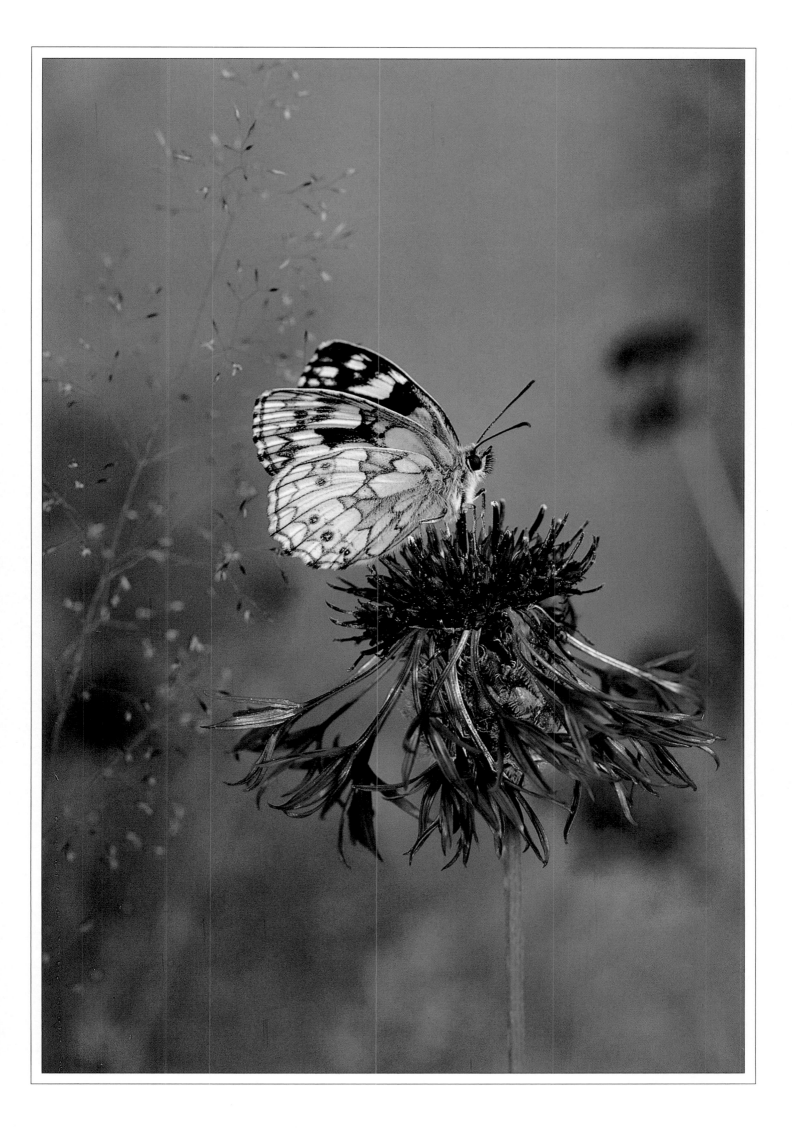

The vast majority of tree frogs live in the tropical rainforests although there is one European species (page 68). Tree frogs are perhaps the most appealing of cold-blooded creatures, with their perpetually grinning faces and large pop-up eyes. Many species are brightly coloured and move by day under the protection of warning colouration. Others, such as this species, the **red-eyed tree frog** (*Agalythnis callidryas*) from South America, are well camouflaged, lying flat and immobile on a leaf during daylight, with their eye sockets contracted into their heads. They wake up at night, to compete with the crickets and grasshoppers with their nocturnal chorus.

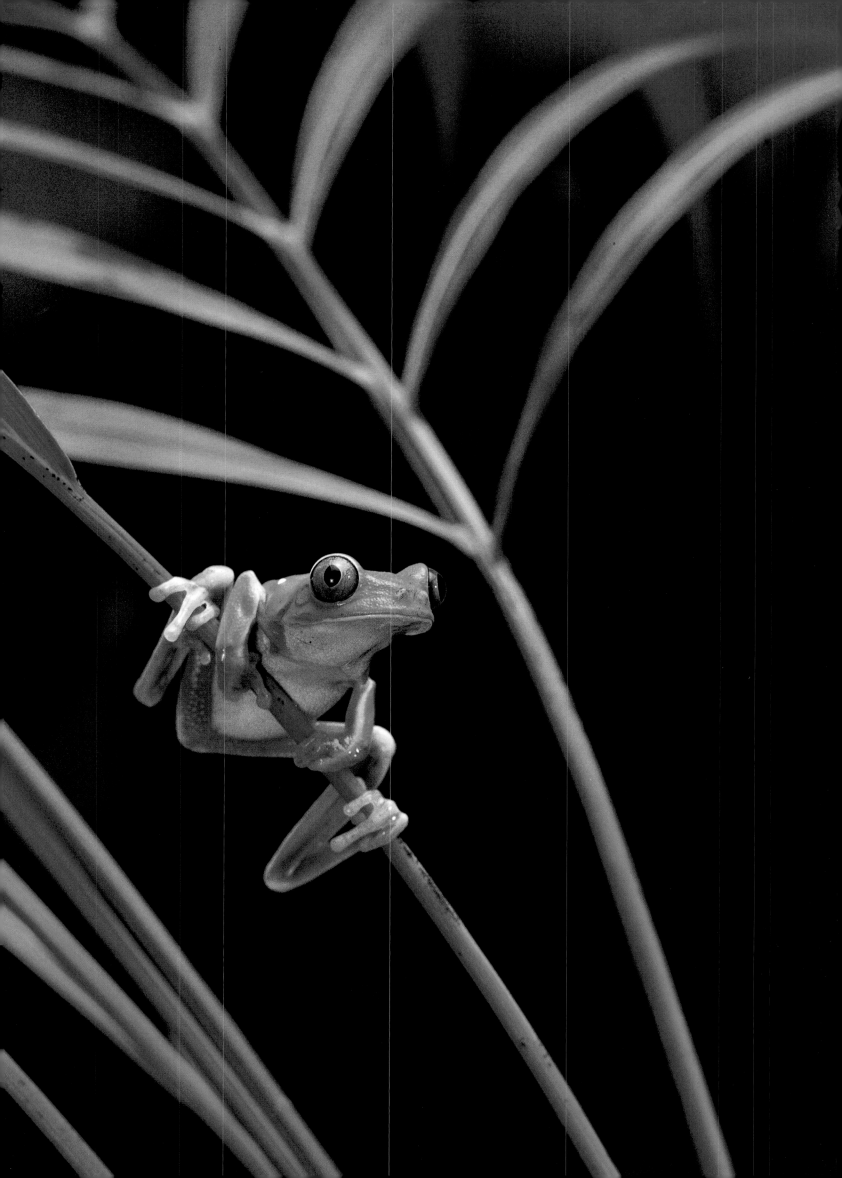

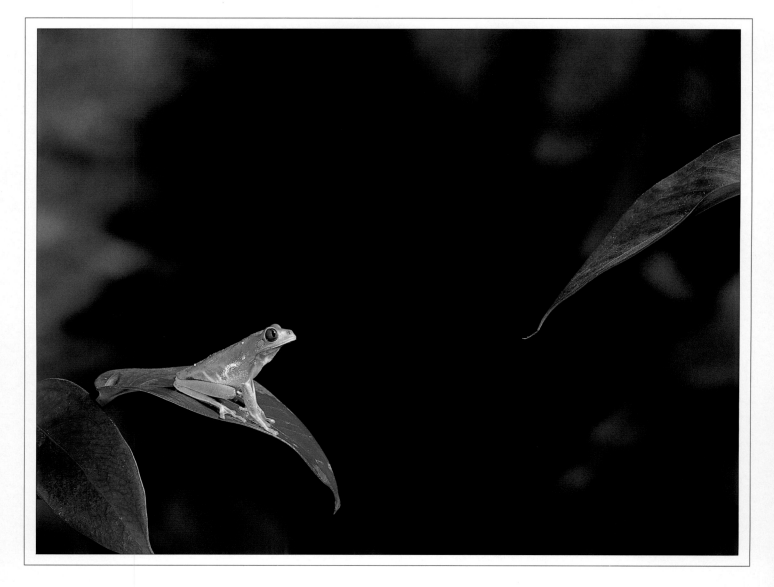

Before taking off, this **red-eyed tree frog** carefully gauges the exact position and distance of its intended landing point or prey and, as it launches itself into the air with its powerful hind legs, the eyes are contracted, jumping blind. This can be clearly seen in these photographs.

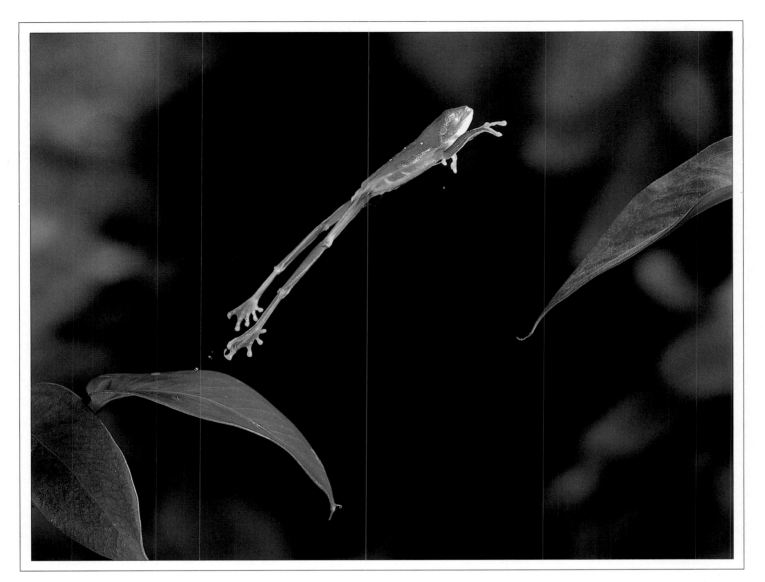

A flat-bodied dragonfly (*Libellula depressa*) emerging, *overleaf*. Insect metamorphosis is always incredible, but the change from a wet, crusty-looking, water-bound nymph to a dragonfly, a winged jewel, is nothing short of miraculous.

After struggling out of the water, the nymph splits its outer cuticle, and gradually the pale, delicate adult works its way out of the nymphal case. Blood is then pumped into the soft, crumpled wings, which harden over the next few hours. At this stage the insect is very delicate and unable to fly.

Although the dragonfly can take to the air some twelve hours after emerging, it takes several days for the wings to assume their full colour and glisten in the light.

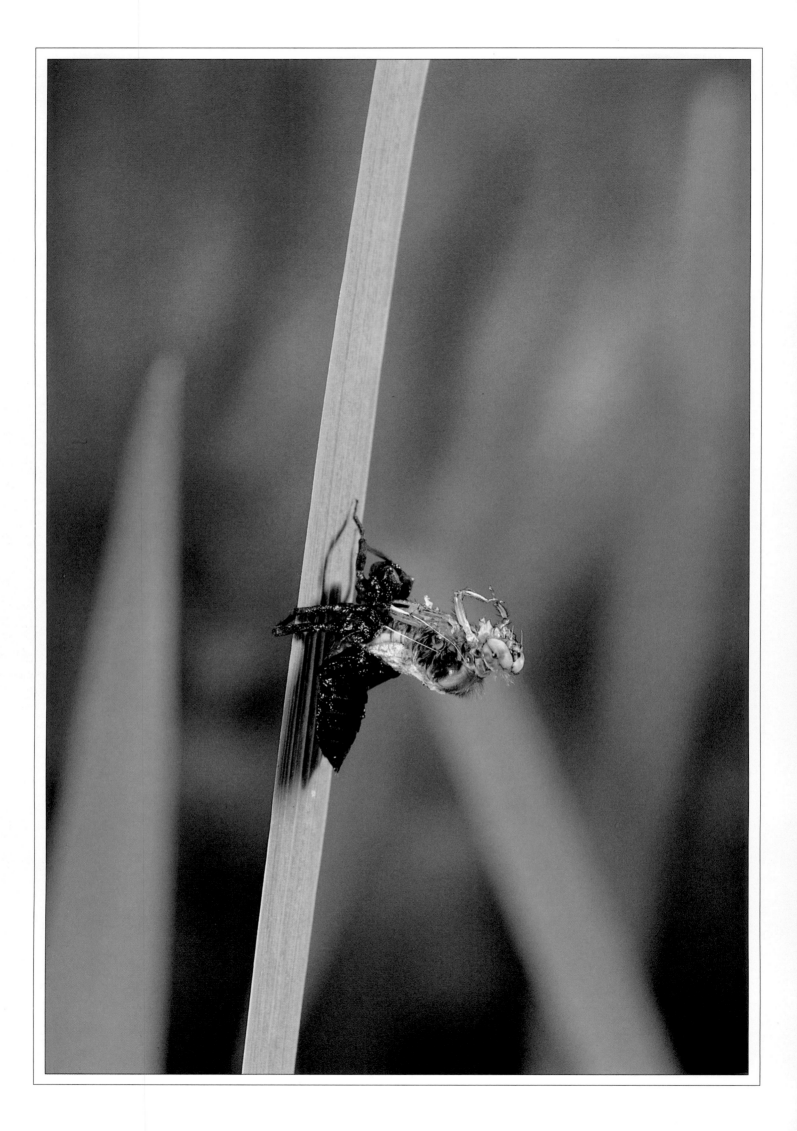

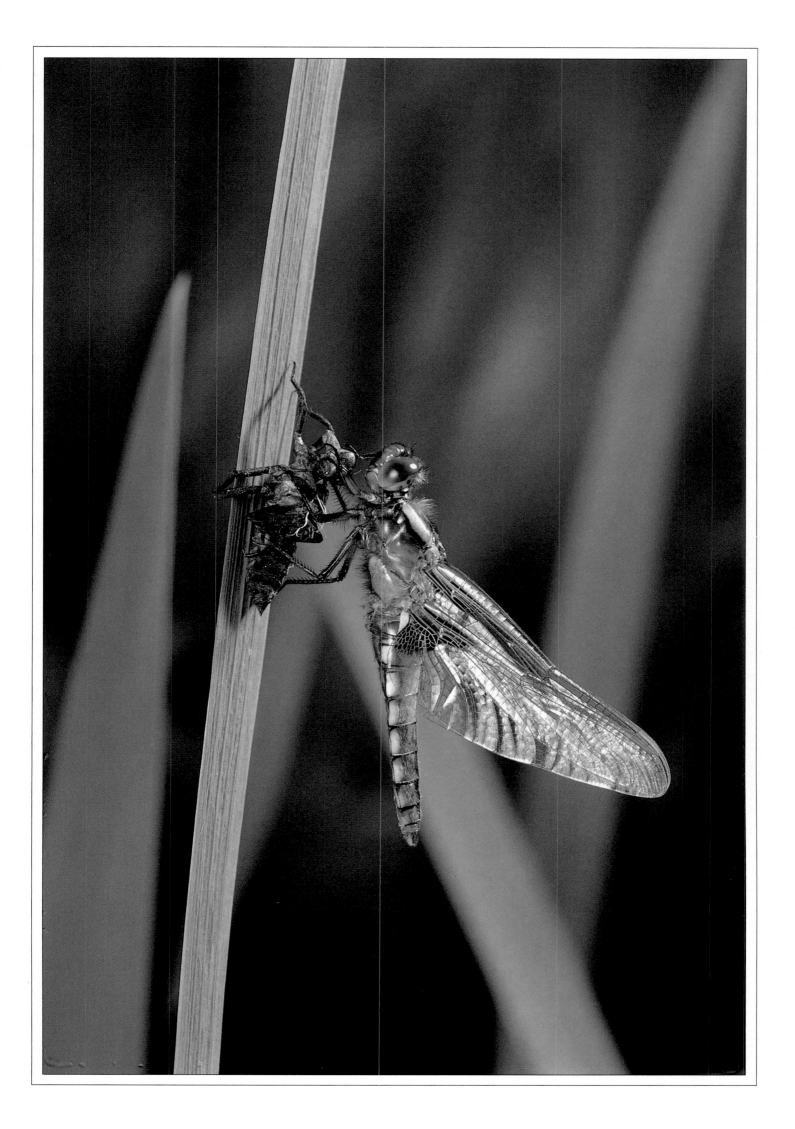

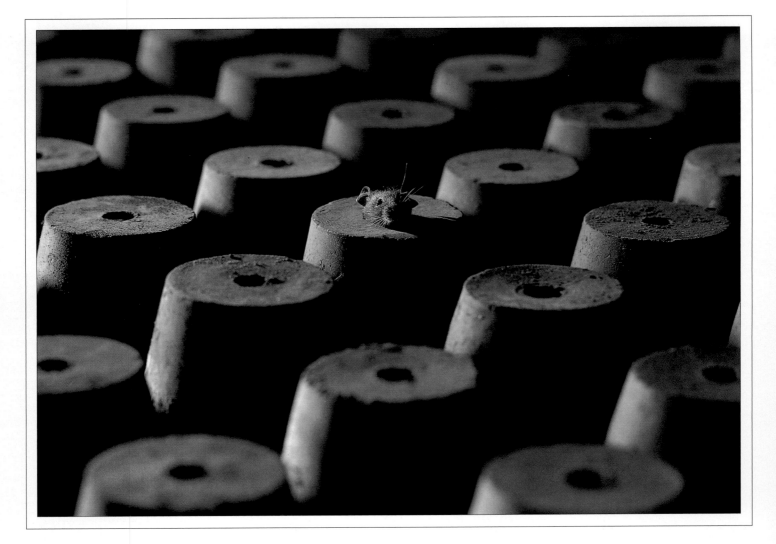

Wherever there is man, there is the **house mouse** (*Mus musculus*). This little rodent has followed us all over the world.

Its success is largely due to its exceptional adaptability. It is not at all fussy about what it eats, and can live happily in the tropics, or can spend its entire life in total darkness, at temperatures never exceeding − 10°C in cold-storage stores. It also has prolific breeding habits, rearing young at any time of the year.

Rather than being threatened by man, mice thrive on his activities. It is sad that we cannot say this for the majority of living things which share our planet.

Although bats may appear somewhat archaic creatures, they are wonderful examples of evolutionary perfection. Here a **long-eared bat** (*Plecotus auritus*) is pursuing a yellow underwing moth (*Noctua orbona*), which has been attracted to an oil lamp. Unlike the more actively manoeuvrable horseshoe bat, the long-eared bat prefers to hunt the slower-moving insects, often hovering before snapping them up. This animal was fed on a diet of moths which it caught on the wing. I spent hours watching it at close quarters, twisting and turning in aerial combat. Sometimes moths could be seen taking evasive action as they heard the bat's ultrasonic squeaks.

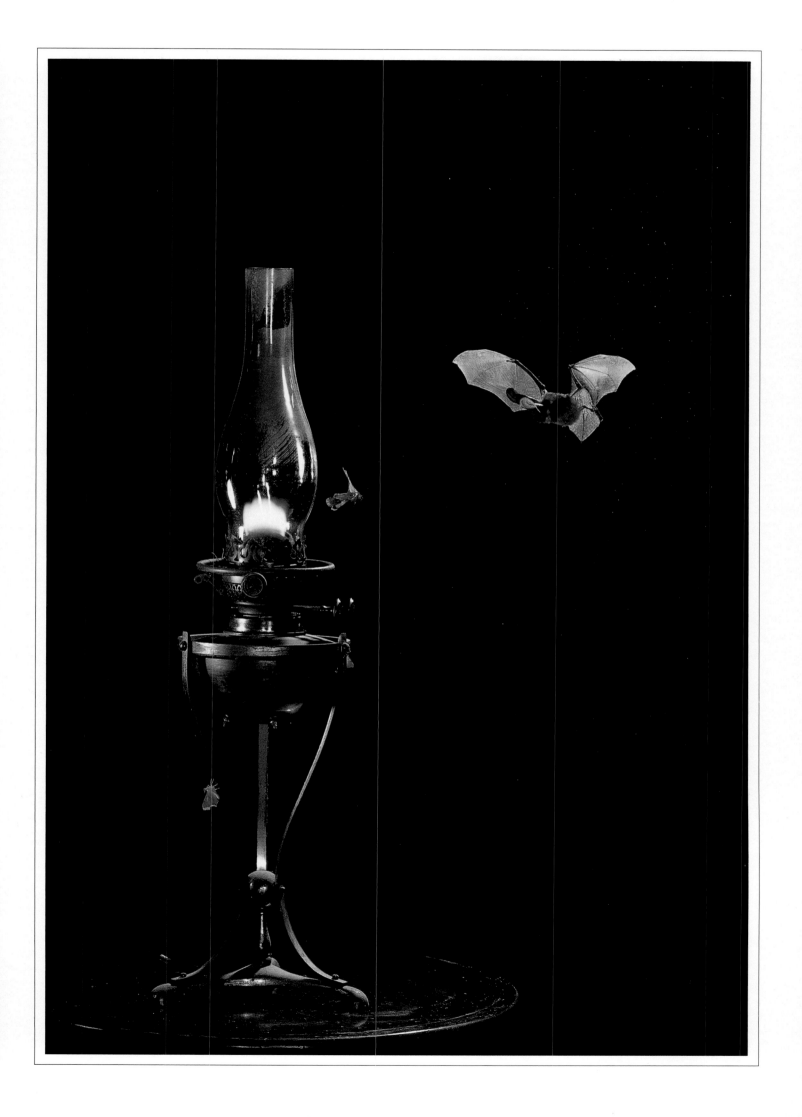

Notes on the Photography

Cameras

The camera model has little to do with results. Nowadays there seems a technological obsession with photographic equipment, brought about for the most part by the camera makers, who find it necessary to incorporate more and more complex gadgetry to sell their wares. Encouraged by much of the photographic press, who discuss and compare at great length all these multi-programmes, auto-this and digital-that, it is no wonder that many photographers find it next to impossible to select suitable equipment.

I have tried these 'state of the art' cameras with their half-dozen metering modes, auto-focussing, digital liquid crystal displays, flashing lights and squeaks, and although they are fine for family snaps, I find them disappointing for serious work. The trouble is that they are not designed for photographers.

Although playing with these electronic toys can be fun, in my experience the simpler the equipment the better. As long as a camera is totally reliable, has first-class lenses, produces minimum mechanical vibration and preferably has a mirror lock, then little else matters. If it is also comfortable to use and has a bit of weight to it, so much the better, as this helps to reduce camera shake – the greatest enemy of sharpness.

When working in the field, I generally use Nikon F3 or FE2 cameras. The F3 is a well-made instrument with a number of good points, but would be much improved by a match needle metering system instead of its digital arrangement, which I find frustrating for manual operation. Thus I often prefer the FE2 (which has match needle) for out-and-about work. Lenses range from 24 mm to 400 mm, and I do not own a zoom.

I also possess an old Leicaflex SL, which I have had since 1967. Made by Leitz, and mechanical rather than electronic, it is utterly reliable, while its lenses are second to none. Nowadays the Leicaflex is only used for flying insects, although two of its Macro lenses have been converted for Nikon use. Most of the close-ups reproduced in this book were taken with Leitz lenses – in fact, the 100 mm Macro Elmar is used for the majority of my photography. For 2¼″-square photography, I have a Hasselblad ELM with three lenses. This is employed chiefly for landscapes and for some birds and mammals. Out of the hundred pictures reproduced here, only fourteen were taken on the Hasselblad, although I am tending to use this format for an increasing proportion of my work.

For ninety-eight per cent of the time my camera is supported by a sturdy but versatile Benbo tripod, a gadget that seems to have been designed for the nature photographer.

Film

The film was chosen to provide the best possible quality of image. Kodachrome 25, or sometimes 64, was used on the 35 mm format, and Fujichrome 50 on 2¼″-square format. Only two of the plates were made from the new 120 size Kodachrome.